D0883540

GARDENS

Drawing and Painting
in Watercolour

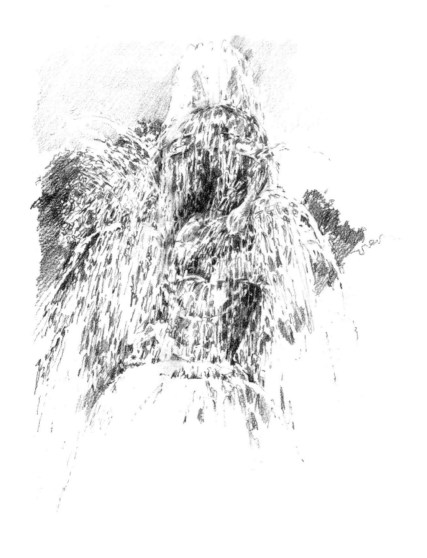

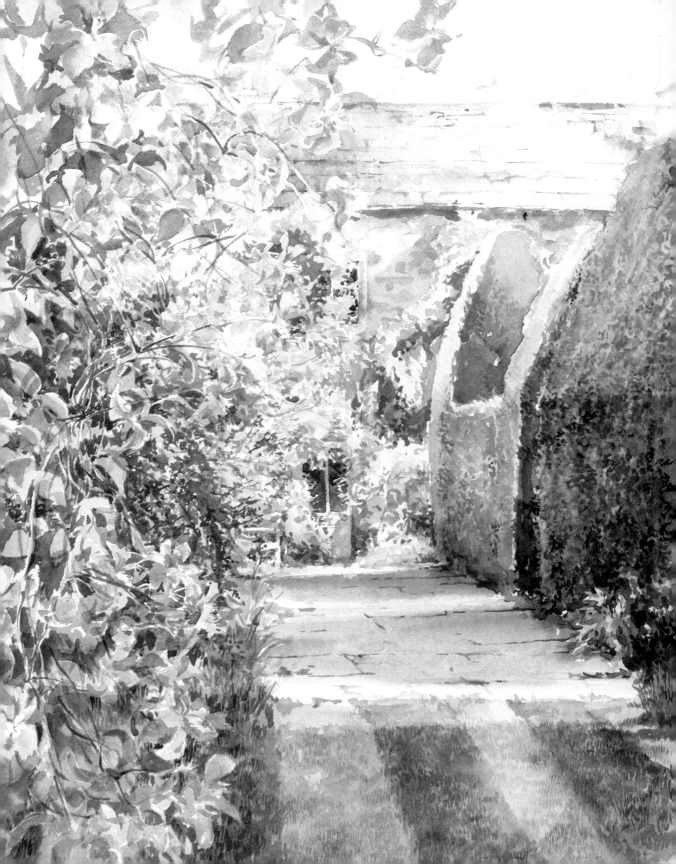

GARDENS
Drawing and Painting in Watercolour

LESLEY FOTHERBY

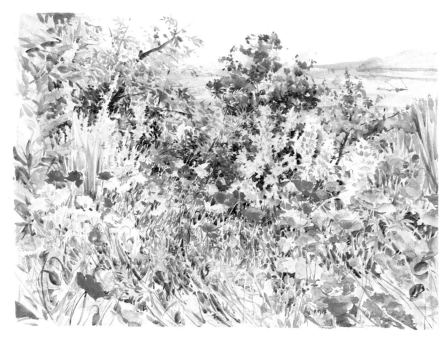

Michael O'Mara Books Limited

First published in Great Britain in 1996 by
Michael O'Mara Books Limited
9 Lion Yard
Tremadoc Road
London SW4 7NQ

A CIP catalogue record for this book is available from the British
Library

ISBN 1 85479 746 8

Designed by Mick Keates

Typeset by
Florencetype Ltd, Stoodleigh, Devon
Printed and bound in Italy
by New Interlitho

Contents

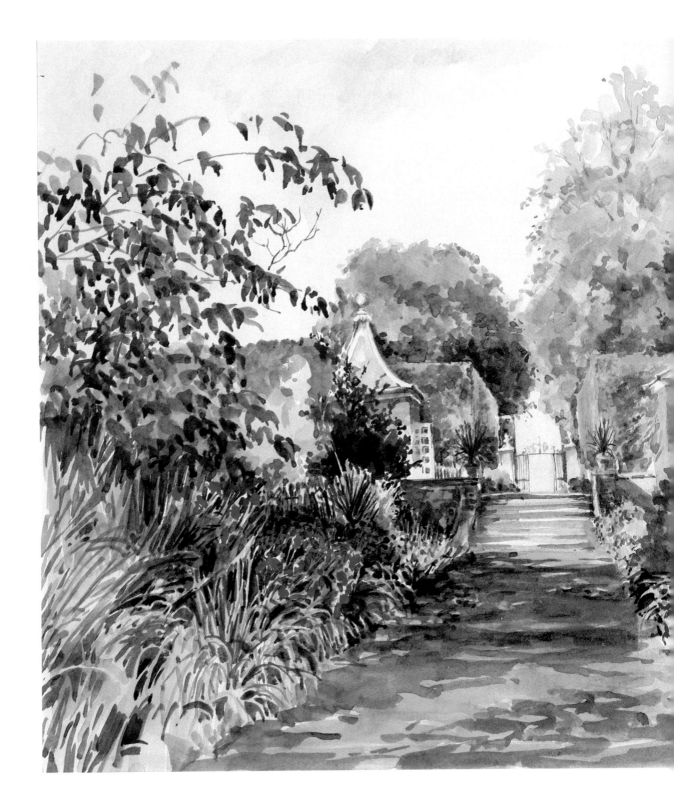

Introduction

Creating a garden is like painting a picture. We choose the colours of flowers and foliage and juxtapose the textures and shapes of trees and shrubs. What is more, it is a picture that changes with the season or the time of day, whether it covers acres or just a balcony. The garden in the bright sunshine of midday will not look the same as it does in the softer light of early evening. Everyone who grows white flowers, for example, will have noticed how much more prominent they look in the evening when they become luminous and shine out from the darker foliage. In contrast, brightly coloured flowers tend to blend in more with the surrounding foliage.

It seems only natural then to try to capture on paper something of the beauty of our gardens. By looking more closely at our subject, it is possible to see the familiar in a new way and so derive even more pleasure. In this book I look at the effects of light and colour and how they change the mood of a picture, as well as how to apply paint and pencil in different ways.

Even if you have done very little painting or drawing before, as a gardener you will already be conscious of colour, shape and texture and so you will find yourself familiar with many of the ideas explored here. Every garden has a different character and I hope you will enjoy recording yours and other people's as much as I do.

Materials

There is a baffling array of art materials to choose from and selecting what you need can be difficult. Let me say first of all that a wonderful drawing or painting can be produced with very basic equipment, for example, the back of a brown envelope and a piece of charcoal. The most important ingredients are yourself, your ideas and enthusiasm. Having said that, you can get a lot of help with your work by choosing the right equipment. Start with the basics and build up from there according to your preferences.

Watercolour Paint

Watercolour paints are a mixture of pigments with a binder, gum arabic and glycerine to keep the gum supple. When mixed with water washes of clear transparent colour are produced, creating an ideal medium for painting the translucency of flowers. As the paint dries very fast, it means that changing effects of light, especially useful when working outdoors, can be captured.

Paint comes in two qualities, Artists' and Students'. You will find that using the best quality (Artists') watercolour paint will help you greatly. The price of a tube or pan will vary according to how expensive the pigment is; any of the paints containing Cadmium, for example, cost more than the basic Series 1 colours, like Yellow Ochre. Note that the cost of a particular colour does not indicate its permanence. There are colour charts available from art shops or paint manufacturers to find out how light-fast a colour is. Although Artists' paint is more expensive, you need only a small amount of pigment to achieve a brilliant colour, so in fact they are quite economical to use. In Students' colours, some of the more expensive pigments are substituted with other substances, and dextrin is sometimes used as an alternative to gum arabic. The overall result is that the quality of the paint is not as fine.

You can buy watercolour paints either in solid blocks – called pans and half-pans – or in tubes. Pans and half-pans have the convenience of coming in boxes, useful if you are painting outside. You can buy boxes with selected paints included or an empty box, which you can fill yourself. You have to soften the pigment with water by rubbing it with a brush and this can be a disadvantage if you want to put down a large area of colour. Tubes contain paint which is more liquid and so more easily mixed with water.

Always mix your paints on something white, the inside of a paint box, a white china plate or a plastic palette. A plastic palette is particularly good for outdoors as it is light. The white background will show you the precise colour that will go on your paper; metal palettes distort the colour and you won't know what effect will be produced.

Gum arabic and oxgall can be added to watercolour paint when it is being mixed. Gum arabic increases brilliancy and gloss, but do not use too much or it will crack. Oxgall eases the flow of colour.

Paper

Because watercolour is transparent the paper you use is very important. Watercolour paper is sized with gelatine, which allows the paint to flow easily over the surface and reduces the paper's absorbency. Good quality papers have a rag content, which means they are acid free and will not discolour with time (unprocessed woodpulp is acidic). A few papers are handmade but the majority are machine-made, the best of which you will find described as mould-made. There are three main types to choose from: 'Hot-Pressed' (HP or fine), 'Not' or 'Cold-Pressed' (CP) and 'Rough'. The surface grain will differ slightly from manufacturer to manufacturer. Most art shops have samples for you to experiment with. Only by trying different papers will you find the type of grain you prefer.

Hot-Pressed has a smooth surface, achieved by passing the paper through hot rollers. This paper is good for detailed work and you can paint very

brilliant washes on its surface, although the paint is more difficult to handle than it is on grainier papers.

Cold-Pressed is also called 'Not' surface paper as it is not hot-pressed. Because it has a light grain, the indentations hold the paint, making it easier to obtain a good wash of colour. It is the most versatile surface.

Rough paper has the most pronounced surface, which gives a broken wash of colour and is most suited to broad washes of paint.

Tinted papers are also available. In the past, if artists wanted to start painting on a coloured ground they used tea to modify their white paper, but now papers can be bought in a variety of tints. Because watercolour is transparent the pale tint will show uniformly through the paint as it is applied, which can give unity to a picture. I personally do not use it, but I offer it as an alternative you might like to try.

Papers vary in weight and consequently in thickness. The weights of papers are expressed in pounds (weight per ream of 480 sheets) or in grammes per square metre (gsm). Usually the weights you will find are 90lb (190gsm), 140lb (300gsm), 260lb (356gsm) and 300lb (658gsm). Hot-pressed paper is only available in weights up to 140lbs (300gsm). I suggest you start with a 'Not' surface paper, of 140lb (300gsm), which is widely available. It may need stretching if you use a lot of water; 90lb (190 grams) weight will always need stretching.* Paper can be purchased in sketch-books or as separate sheets (56cm × 76cm), in which case you will see a watermark in the corner. When you can read this the right way round you are looking at the right side of the paper, although either side can be used.

Paper can be tub-sized, which means that a coating of gelatine has been applied to it after production, and/or internally sized, the size having been introduced earlier in the process. Both methods give consistent results.

Most of this information appears on the back of sketchbooks or packs of paper.

*Wet the paper thoroughly with cold water and hold it up by two corners until excess water drips off. You will see the paper fibres expand. Place the paper on to a wooden board and secure it with gummed paper tape. Leave the board lying flat until the paper has dried and the wet fibres have contracted to give you a taut surface.

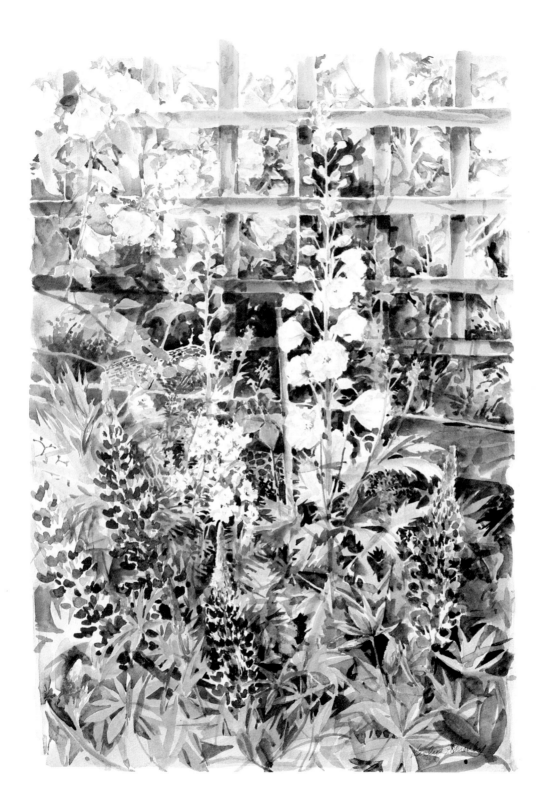

Brushes

Your brush brings together the paint and paper, and the type you use, to a large extent, will determine the marks you make and how the painting eventually looks. If you choose a versatile one, it will allow you to apply either a flat area of colour or build up texture and pattern with small, broken strokes.

The finest brushes for watercolour are sable. The hairs are springy, tapering to a fine point, and they also hold their shape well; Kolinsky sable are the best. They are flexible, allowing you to use either the fine point for delicate lines, or, by pressing firmly on to the paper, apply more paint from the reservoir of the brush, the part where the brush bulges and holds most paint. They are expensive, but will last for a long time and you only need one or two to start with. Brushes which are a mixture of sable and nylon are more reasonably priced and a good alternative.

A large variety of other brushes is available, all enabling you to achieve distinctive marks. Squirrel brushes have softer hairs than sable and so are more difficult to control, but they can give a good, soft-flowing line; the large type of squirrel brush is dome-shaped and good for applying washes. Ox-hair brushes, used square-ended, are excellent for putting down broad strokes of colour. You could also try some oriental brushes, usually made of a mixture of hairs, which again allow a wide variety of marks.

Sable and sable-mix brushes range in size from 0 to 14. Start with a 6 or 8 which hold plenty of paint, and let you paint broad washes and fine lines. Unlike oil painting, you can if you wish use one single brush for an entire watercolour painting, and still create a range of marks.

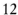

Watercolour Painting

While looking at the materials we need for watercolour painting you will have noticed in the descriptions of their qualities, i.e. the light reflecting surface of the paper and the transparency of the paint, how important it is to achieve a clear wash of pigment. It is the pigment that allows the light to penetrate to the paper and reflect back. So that this can happen I must stress how essential it is to have lots of clean water. This may seem rather obvious, but many people struggle with a tiny water container, which gets more and more murky, and it is so disappointing not to be able to mix a clear colour because you are picking up bits of other pigments already dissolved in the water. Have a large jar by your side and change the water frequently. Remember, this is the medium which will carry your paint over the paper – let it help you, not hinder you. Ideally, distilled water should be used as some of the chemicals in tap water can affect the paint causing it to become granular, but what you use is not crucial – just plenty of it!

Most of the colours you will want to use can be mixed from a basic palette. There is no white, of course, because light colours are achieved by adding water to the paint; the more water, the paler the hue. White makes the paint opaque, and actually stops the light passing through the paint and reflecting off the paper, resulting in a dull effect.

The Basic Palette

You will need the three primary colours: yellow, red and blue. Because of the different qualities of the hues I have chosen two yellows, two reds and three blues, cold and warm hues of each:

Yellows		*Reds*	
Lemon Yellow	cool	Alizarin Crimson	cool
Cadmium Yellow	warm	Cadmium Red	warm

The Basic Palette

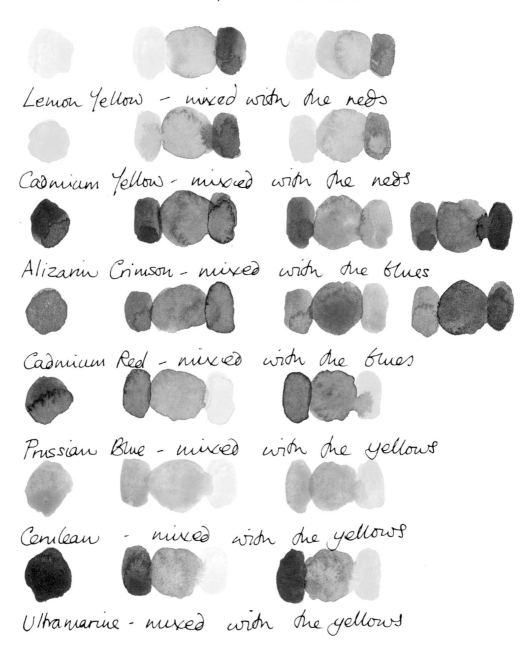

Lemon Yellow — mixed with the reds

Cadmium Yellow — mixed with the reds

Alizarin Crimson — mixed with the blues

Cadmium Red — mixed with the blues

Prussian Blue — mixed with the yellows

Cerulean — mixed with the yellows

Ultramarine — mixed with the yellows

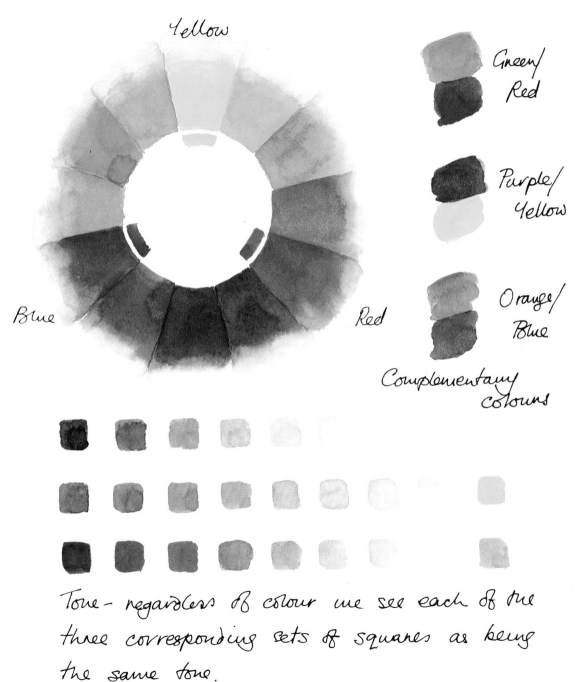

Colour Chart

Yellow

Green/Red

Purple/Yellow

Orange/Blue

Complementary colours

Blue

Red

Tone- regardless of colour we see each of the three corresponding sets of squares as being the same tone.

Blues

Prussian Blue	cool
Cerulean	cool
Ultramarine	warm

As well as the primaries, you will need these earth colours:

Yellow Ochre	beautiful soft colour – indispensable
Burnt Sienna	hot brown
Sepia	cool brown

Cool colours tend to recede, and warm colours come out of the paper.

Mixing Colours

We are used to thinking of reds as warm colours because we associate them with fire, and blues as cool colours. We say we turn blue with cold, and it is right to think of them in this way. Similarly we think of yellow in terms of the warmth of the sun. However, within all of these colours there are degrees of warmth and coolness and it is important to understand the differences between the hues because here lies the key to mixing colours, and to using the right colour to create the desired effect.

Yellows
Lemon Yellow, which is at the top of the diagram on page 14 is a cool, acid colour. Compare it to Cadmium Yellow underneath; this yellow has red in it and shines out of the paper at us. When mixed with red, Cadmium Yellow makes a purer, brighter orange, Lemon Yellow a more delicate peachy colour.

Reds
Alizarin Crimson is a cool red, because it has blue in it, and as you can see makes the clearest purples. Cadmium Red, the colour of fire, is more

orangey, and so when mixed with blue the resulting purples tend towards brown.

Blues

Prussian Blue is an intense, cool, greenish blue. Cerulean is a lighter tint, and is also cold. Both give the purest greens. Ultramarine, another powerful blue, is much warmer, and although it also mixes to form a lovely green, you will see it is a more muted, browner one. This is because Ultramarine has some warm red in it. Red + yellow + blue will make brown and so the red in this blue will affect any green which it is used in.

When Sir Isaac Newton directed a beam of light through a glass prism sunlight was split into a spectrum of colours. From his researches we know that objects appear to be a particular colour because they reflect different parts of this spectrum. For instance, a blue sheet of paper absorbs all the colours of light except blue which bounces off its surface. The colour wheel was developed from this division of sunlight into the colours red, orange, yellow, green, blue, dark blue and violet. Look at the diagram on page 15 to see how colours are mixed and how cool colours contrast with warm ones.

Look at the three primary colours and then across to the colour which is opposite each of them in the circle:

Yellow is opposite Purple (blue and red mixed)
Red is opposite Green (blue and yellow mixed)
Blue is opposite Orange (red and yellow mixed)

These pairings of colours are called complementary colours and if they are used together they produce a brilliant, vibrating effect. The Impressionists used small strokes of complementary colours together to make the surfaces of their paintings shimmer. If you look at the red and green pairing on the colour wheel you will see how close in intensity the two colours are. I have used red and green to illustrate how different colours can have the same tonal values.

The series of grey squares graduate from dark to light. Underneath, I have painted a series of green and red squares, each corresponding to the same tone. Regardless of the colours, we see the corresponding sets of

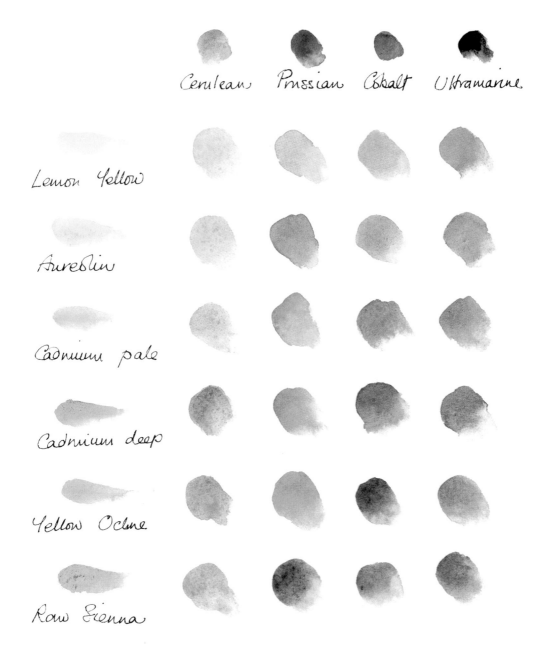

Cerulean Prussian Cobalt Ultramarine

Lemon Yellow

Aureolin

Cadmium pale

Cadmium deep

Yellow Ochre

Raw Sienna

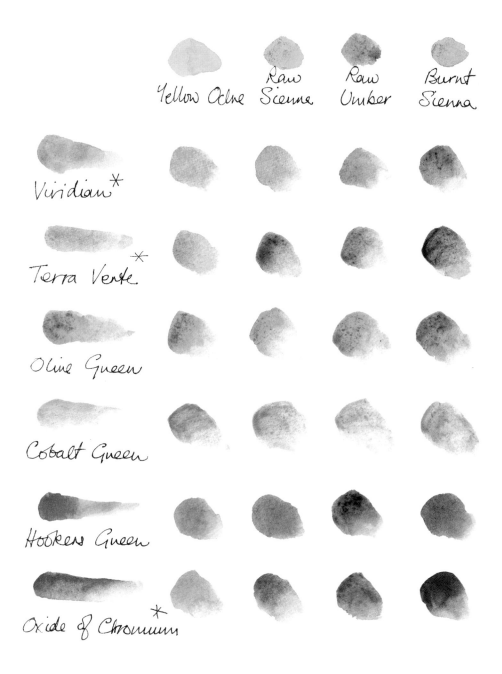

Yellow Ochre

Raw Sienna

Raw Umber

Burnt Sienna

Viridian*

Terra Verte*

Olive Green

Cobalt Green

Hookers Green

Oxide of Chromium*

squares as being the same tone. The yellow and purple on the wheel have a strong light/dark contrast but, by lightening the purple (bottom right, page 15), we can give them the same intensity. *The Red Border at Hidcote* on page 6 was painted using almost exclusively reds and greens, and the feeling of space and form is largely created by using different tones of these colours. In the bottom right-hand corner is a group of red flowers among dark green foliage. Half-close your eyes and look again at this section. It will be more difficult to distinguish the two separate colours but you will be able to judge the difference in tone of one thing against another. This very dark area pulls our eye to the foreground of the picture, whereas the very light green of the tree behind the hedge gives the feeling of distance and so helps create the illusion of space.

Greens

Greens are probably the most difficult range of colours to mix and use. There are so many different greens, and it is all too easy to make them too bright and harsh. Greens, however, are obviously so important when painting gardens that they need to be examined in greater detail than the other colours.

On pages 18–19, I have mixed some greens using a variety of blues and yellows, the ones from the basic palette plus a few more interesting colours. Added to the blues is the warm Cobalt Blue, which makes a slightly less intense green than that made with Ultramarine. To the yellows I have added Aureolin, a beautiful, clear yellow – between Lemon and Cadmium on the temperature scale. Cadmium Yellow makes a deep green, Raw Sienna makes a more earthy green.

If we look at the results, we can see the clearest greens in the top left-hand section, where the cool blues are mixed with the cool yellows. The warmer yellows tend to give denser, although equally beautiful colours; Raw Sienna and Prussian Blue, for example, are a very useful combination. Already we have a wide selection of greens and this is only the start.

Each of these combinations can yield many more just by altering the

proportions of the two colours used. Put all the blues you have along one edge of a piece of watercolour paper and all the yellows down another (it doesn't matter if they aren't the same ones I have used). Try to group all the cool colours and all the warm colours as I have done, and then start to mix; the more you do this, the more you will find yourself able to predict the type of green you'll end up with, and this helps with what can be a rather haphazard process when you are out in the garden trying to achieve a particular colour.

There are many greens which you don't have to mix yourself as they are available ready-made. Each owns particular characteristics. Here are six:

*Viridian** is a clear almost turquoise green, which has to be bought ready-made. When it is mixed with any of the earth colours (along the top of the page), it gives a lovely, subtle green.

*Terra Verte** is a very transparent, delicate colour, useful for the green leaves.

Olive Green is also a transparent pigment, but a more robust colour. We achieved a similar colour when we mixed blues with Cadmium Yellow.

Cobalt Green is a delicate blue-green. Mixed with the warm Burnt Sienna, it appears as if a pink is showing through.

Hooker's Green is a strong pigment, so be careful with this one! It is the sort of green which you find in rhododendron leaves and in other shrubs with thick, shiny foliage.

*Oxide of Chromium** is one of my favourites, and can be very useful. It is one of the most opaque of the watercolour pigments, so care needs to be taken if you are using a dense mixture of this colour.

Artists' colour charts giving the whole range of colours are available from art shops. Buy a chart that provides you with actual washes of pigment rather than a printed reproduction of the colours. Start with the basic palette and build up gradually from there.

*In my opinion, these are the best of the greens; they are all very permanent.

Starting to Paint

When you are first starting to paint, especially in watercolour, it is important not to spend too much time drawing your subject before you start painting, otherwise, you will feel constrained to work within the marks you have put down, resulting in a rather tight and formal work. Also, you will sometimes want to work quickly to catch a particular light or mood, and a direct approach will enable you to achieve this. Don't be daunted by the direct approach. You will soon find that it is not as difficult as it seems.

NB If you are planning to paint private gardens, please be sure to ask permission first.

Working with Paint and Paper

Familiarize yourself with the following techniques, which will be very important as you develop a painting style of your own.

Laying a Wash

This is a method of applying a flat area of paint to a surface. Attach a piece of 'Not' surface paper to a board, lay this flat on a table, and then put a couple of books or a box under the end furthest from you so that the board is tilted. Mix a quantity of paint using plenty of water so that it is quite diluted and load your brush (a No 6 or 8) with it. Starting at the top left-hand corner draw a line of pigment horizontally across the paper using the side of the brush (so that the reservoir is in contact with the paper). When you get to the end of the line lift the brush, go back to the side you began at and draw another line slightly overlapping the previous one. The board is at an angle so gravity will make the water flow downwards and each line will merge into the next.

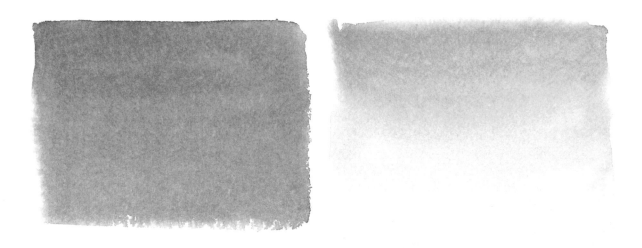

A Graded Wash
Here an area is covered unevenly because the paint is more dense at the top. Proceed as with the previous technique, but each time you apply a brush stroke add a little more water to the mix. Again, the force of gravity will draw the water downwards. With both these techniques make sure you have mixed sufficient paint to cover the area you want to paint before you start. There is nothing more frustrating than having to re-mix halfway through; it is unlikely that you will end up with a consistent wash.

Pulling out Pigment
Put a large blob of paint on to the paper, with more paint and less water than before. Rinse your brush and while it still has only water in it return it to the painted area and pull the paint outwards. See how the water carries the paint gradually across the paper (we are not relying on gravity this time, but on the pigment being pulled across with the flow of the water). Do not be afraid of putting water on to the paper when you are painting. Let it help you. I know it feels as if the water is in control and not you, but this isn't the case. You can always push it around with your brush or mop it up with a paper towel.

Brush Strokes
These show the versatility of a sable brush on dry paper (use whatever brushes you have). Firstly, use just the tip of your brush and, barely touching the paper, draw some lines across the paper. To get a smooth line, use the curving action of your wrist to pull the brush across as quickly as possible. Now, with plenty of paint on the brush put on more pressure and pull the side of it over the paper. As you gradually lift off the brush the mark will get thinner.

Wet on Wet
This is the method of painting on to damp paper. Wet a part of your paper with either your brush or a small sponge, and where the paper is still damp draw into it the lines you made in the previous exercise. The effect will be soft and more diffuse. Try this several times allowing the paper's surface to dry out slightly between each application and you will see the different effects you can achieve.

Exercise: Still-life of Indoor Plants

Before actually going out in to the garden to paint, it will be useful to use some of the techniques on indoor plants. It is also important to start looking at how plants grow together, which will be invaluable when you venture outside.

Collect five or six houseplants. Any will do as long as they are all different from one another. Group them together on a table, so that their foliage intermingles. Take a piece of 'Not' surface paper, as large as possible (I have used a full-sized sheet, 56 cm × 76 cm), and a large brush, No 6 or 8. The paints you need are the yellows and blues from the basic palette, plus Alizarin Crimson and Burnt Sienna.

With the tip of your brush, make several free, curved lines to indicate where the stems of the plants are. I started with the palm. Next, I indicated the position of the central veins of the broad leaves. On the right-hand side, I pressed down on my brush to fill in the leaves of the bromeliad, and finished the leaves of the fern in the foreground. Next, I painted the lily. Do not worry if your first marks are not in precisely the right place. What we are after is the character of the plants and how they look as a group.

Now that you have the skeleton of the picture, start to put in more solid shapes and build on the existing lines. If you look at my painting at the bottom of page 26, you will see that I have painted in the nephrolepsis fern behind the bromeliad so that the shape of the bromeliad's leaves shows more clearly, making the painting three-dimensional. Principally I have used greens, but where plants have some red or brown in them I have indicated this, usually along their central vein. As you progress, look for where the dark green areas are, probably towards the base of the plants where the leaves are closest together.

In my third picture (page 27), the leaves at the bottom of the palm are crammed together, creating interesting triangular and rectangular shapes. The impatiens on the left has white flowers and I have painted round these, leaving white paper for the petals, a technique explained on page 64.

After painting the structure of the plants, you can begin adding the leaves' patterns. Notice that I left the stripes on the bromeliad until the end. If I had put surface pattern on before, I might have lost the basic form

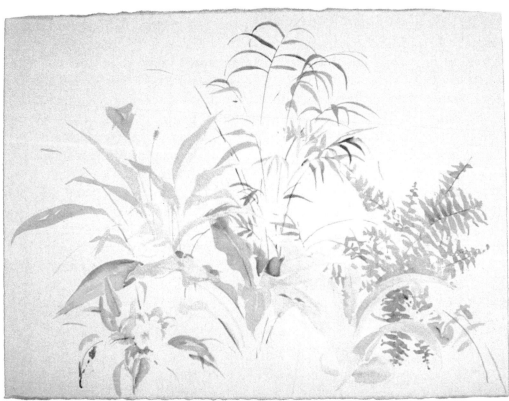

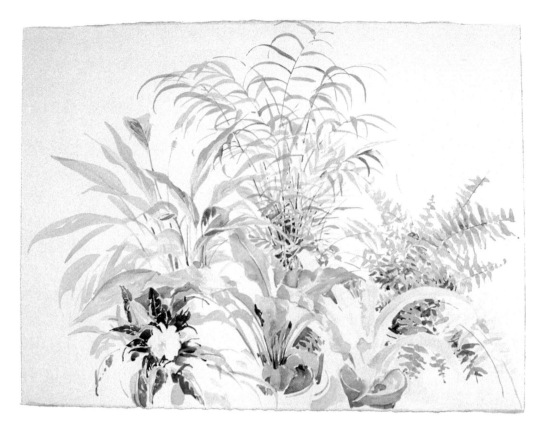

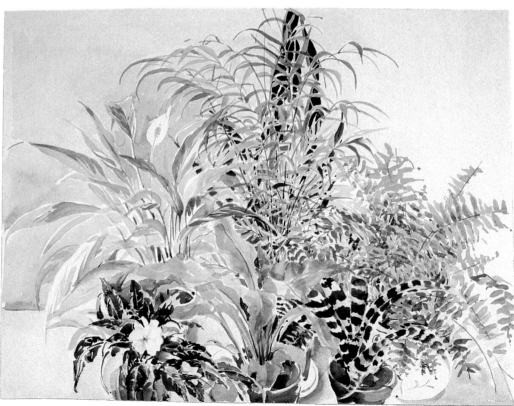

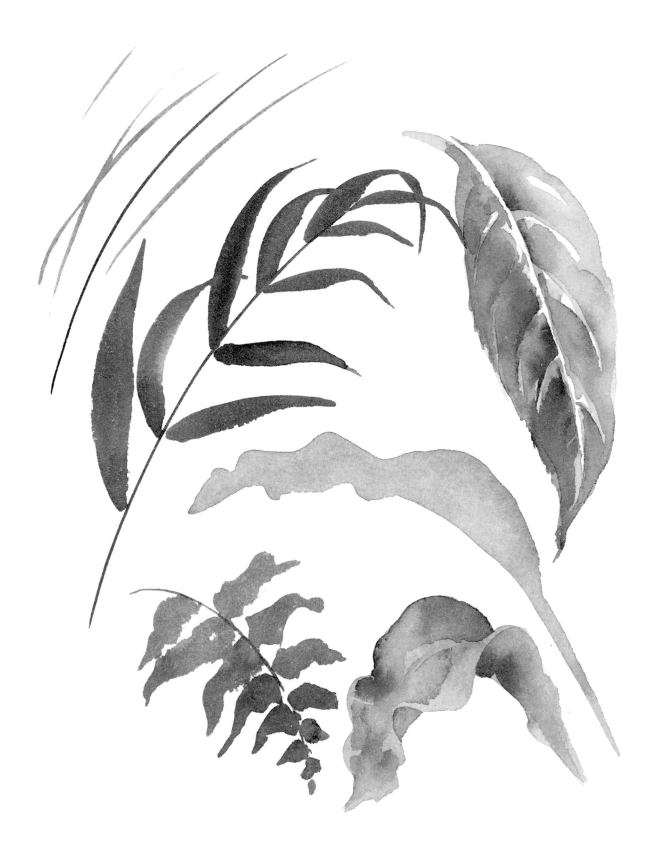

of the plant. Finally I painted in a light wash to show up the lilies, which gave depth to the picture.

I find it very useful to catalogue the various shapes of my drawings and paintings. The following notes were made of the plants I used in the still-life on pages 26–27. Try some similar ones using the plants you have chosen; the methods I describe can be applied to any leaves.

(1) These lines were made swiftly, using just the tip of the brush gently touching the paper. I held the brush fairly loosely, without gripping too hard, so I could achieve a flowing line. The curving action of my wrist helped as a guide.

(2) I drew a line as above for the stem of a parlour palm, each leaf on that stem being painted with one stroke. The tip of my brush, heavy with paint, I placed where the leaf meets the stem. Then I pressed down so that the side of the brush was on the paper and the paint in the body of the brush created the broad part of the leaf. As I pulled the brush over the paper, I lifted it gently so that the leaf could taper towards its tip. By this time only the very end of my brush was in contact with the paper.

(3) For the nephrolepsis fern I moved my paint brush from side to side as I made the stroke, so I achieved a rather crinkled effect. Notice how differently the leaves are spaced from the palm. The asplenium fern's leaves are also painted with one stroke, broader this time and using more dilute paint. I have painted two leaves, the first just showing its silhouette. For the other, I wanted to achieve a three-dimensional effect, so I waited for the first layer to dry and then added more pigment to the areas in shadow.

(4) For the impatiens leaf, I applied the paint in broad sweeps between the veins, starting at the centre and pulling the paint out. I then darkened one side of each of these strokes to show how the areas between the veins are raised, like hummocks.

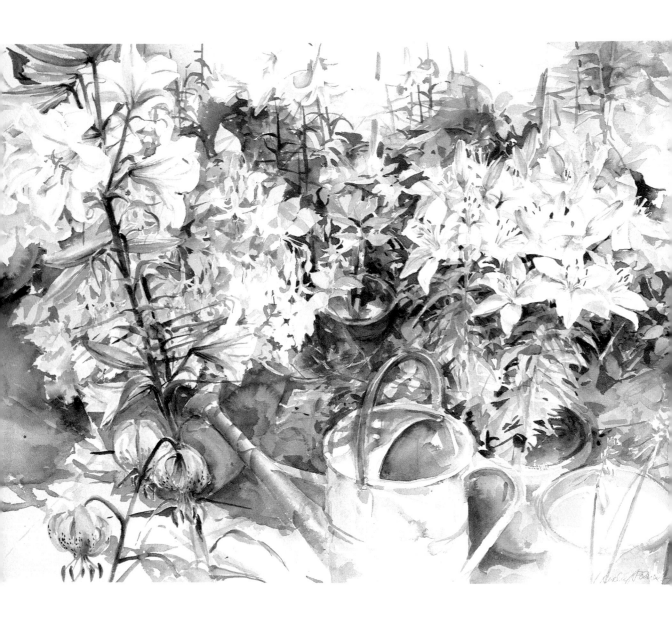

What to Paint?

Choosing what to paint or draw can be difficult. We tend to think we must find the perfect viewpoint, at a time when the garden looks at its very best. If we did this, however, we would paint about one picture a year and miss many opportunities of wonderful and unusual subjects. The seemingly mundane, like a pile of plant pots or the vegetable patch, are worth recording too, as you will find when you look at them in a new light. To help find these subjects we need to look carefully and home in on a part of the garden, potting shed or conservatory. A useful device for doing this is a viewfinder; you can make one by cutting a rectangular hole from a piece of thick paper or card. The dimensions do not matter too much (the smaller the hole the nearer it needs to be to your face when you look through it), but make sure the proportions correspond to those of the paper you are going to work on.

Hold the viewfinder upright in front of your line of vision and move it around so that you are seeing different parts of your subject isolated within its frame. This makes choosing what to paint or draw much easier.

You could attempt your first garden picture looking out of a window, using the frame as your viewfinder if you like and move around the room until you can see the right bit of garden. Do not make a detailed drawing of what you see before starting to paint. However, you do need to work out what you are going to paint and to do this preliminary drawings are essential.

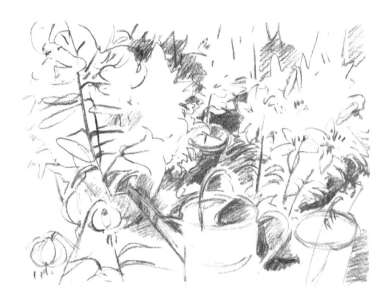

These are *rough* sketches, which will give you an opportunity to play around with compositions. The drawings need contain only a bare outline of what you see, just enough to tell you where things are in relation to each other and to the sides of the paper, and where the principle areas of dark and light are. The charcoal drawing above is the preliminary sketch for the picture (page 30). I made several drawings before I chose this composition, giving me just enough information to begin the painting.

Start your painting in the same way as we did the still-life of the plants. Put in a few basic lines, which you can 'hang' the rest of your picture on. The illustration on page 31 will show you how I started my painting.

You will see that, as before, I have put guide marks all over the paper so that I can compare the different subjects, for instance the angle of the lily stem with the spout of the watering can. Try, as you progress with your painting, not to concentrate on just one area at a time. I found the lilies so beautiful that it was difficult not to give them all my attention. However, the dark background in contrast provided their outline and the colour differences, and I concentrated on these areas first.

Drawing Materials

Anything from a pencil to a piece of twig dipped in ink can be used for drawings, whether they be detailed studies, or a quick working sketch where the most important thing is to get a varied line and a wide range of tone onto your paper as quickly as possible.

When you start to draw it is a good idea to experiment with the medium you have chosen and see what effects you can get with it. Take a soft pencil or a piece of charcoal and shade in an area of paper pressing as hard as youcan to get a really dark tone. Then release the pressure and gradually the tone will become lighter until, when your pencil is hardly touching the paper, you will get the lightest shade. Now draw just a line, rather than shading. Practise broad sweeps of line across the paper, and try not to clutch the pencil or charcoal too firmly. Relax and use the action of your wrist to get a long, continuous line.

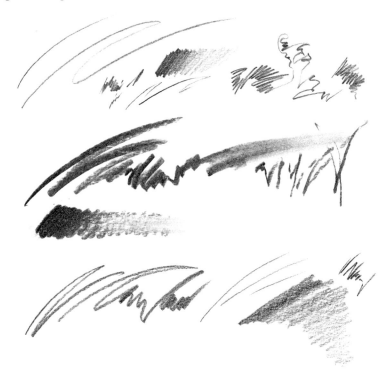

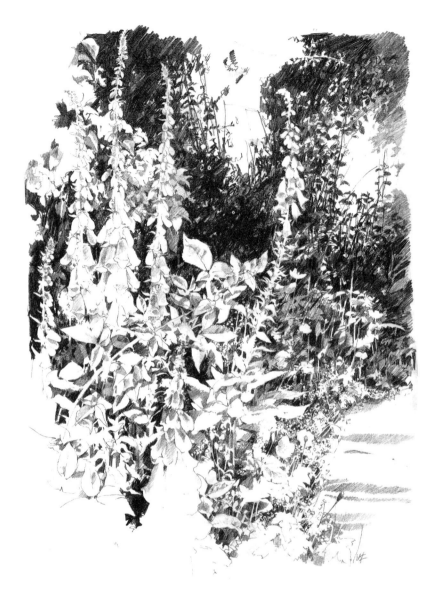

These two drawings of foxgloves in a border, above and overleaf, were done using a 6B pencil and charcoal respectively. They show two different approaches to the same subject. The pencil drawing is a detailed examination of the border containing a lot of information, including the texture of the plants and the patterns they make as they grow together, as well as being a delightful drawing to do in its own right. The charcoal sketch, on

the other hand, is a quick representation (about ten minutes) of the same view, giving just the basic information about composition, light and shade; it is the sort you need as a preliminary study.

Notice that I have varied the pressure on my pencil and charcoal for the lines and shading to give interest. You can see how important and interesting it is to have this repertoire of techniques at your disposal.

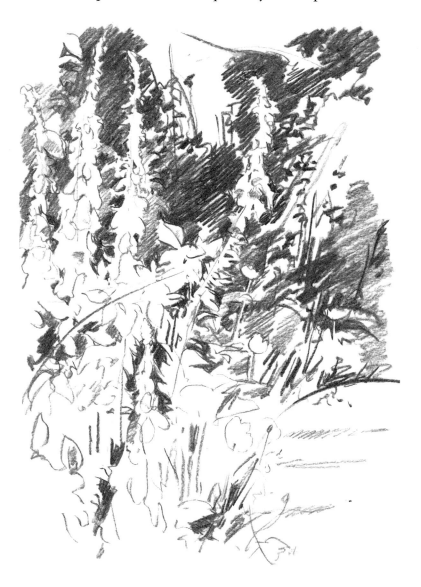

Pencils

Pencils vary according to the softness of the lead. The softer the lead, the blacker the mark, and consequently the greater the range of tone obtainable.

Pencils are marked with a letter and number on their shank.

6B 5B 4B 3B 2B B HB F H 2H 3H 4H 5H 6H
←——— soft ———→ ←——— hard ———→

The best ones for drawing will have a B on them, and for the purposes of making either quick preliminary sketches or detailed reference drawings use one between 6B and 2B.

6B

5B

4B

3B

2B

B

HB

Look at how the marks differ from those at the other end of the scale.

H

2H

5H

Charcoal

A wonderfully versatile medium, soft and crumbly, charcoal gives a very black line, which can be made lighter by rubbing with your fingers. So many effects are possible.

Conté

A range of crayons that come in all colours, but the ones you will find most useful are the black and the greys, the black being slightly harder than the grey. Conté are not as easily rubbed away as charcoal, so to get a lighter line, use less pressure than you would with charcoal. There are many subtle variations of grey Conté, which will produce different textures, particularly if you use them on a pastel paper (like Ingres or Mi-Tentes) or on a 'Not' watercolour paper.

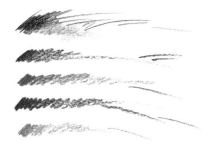

Papers

You can draw on any paper, including watercolour paper, and the surface of papers will affect your drawing as much as the medium you use, so experiment with different combinations. Here are some examples of good, easily available papers.

Cartridge Paper

So called because in the past it was used to wrap gun cartridges. This paper has a smooth surface and is probably the most versatile drawing paper available. It can be bought in sketchbooks (A1 – A5 sizes) or sheets (A1 size 841mm × 594mm), and comes in two weights 130gsm and heavy-weight 220gsm.

Bond Paper

An even smoother, lighter-weight paper, widely available in sketchbooks.

Layout Paper

Very thin white paper (50gsm), with a smooth surface. It is extremely useful for making quick preliminary sketches and experimenting with compositions as you get a lot of sheets in one sketchbook.

Pastel Paper

Pastel papers come in a wide variety of colours. They are textured and each manufacturer's paper has a distinctive surface. For example, Ingres has a surface texture made up of close parallel lines, Mi-Tentes a honeycomb effect. You can buy a selection of colours made up into a sketchbook but, before you do this, check you like all of them – some of the colours are very bright and quite unsuitable as the basis for a garden drawing. It might be better to buy separate sheets of the subtler tints. Buy good quality pastel paper and ensure it is acid-free, so that there is no chance of the colour fading or the paper becoming brittle.

Watercolour Paper

As we have seen on pages 9–10, these papers are available with a variety of surface textures. The best for drawing are the smooth 'Hot-Pressed' and the ones with a slight tooth, i.e. the 'Not' surface papers.

Working Outside

By now I am sure you will be keen to get out in to the garden to paint. The paper you can take out will be either ready-stretched (see page 10) or fastened to a board with clips or masking tape. If you have a sketchbook, the paper in it should be sufficiently supported. It is possible to work, if you sit down, with the board resting on your knees and supported at the other end by the back of a chair. However, this means your movement is rather restricted, especially if you want to stand back and view the painting from a distance. It is better to find a small table on which the board can be supported at an angle, perhaps by a couple of books, which will give you somewhere to put your paints too, although you will have to stand up. Alternatively, use an easel. You want an easel with an adjustable angle at the centre so that the board is not too upright and you don't have to worry about catching the water as it rushes down the paper.

I use a table if I am working in my own garden and a lightweight easel when I am painting in someone else's garden. If I am painting in a garden which is open to the public and where I do not want to be too intrusive, I just take a folding stool and a board with some paper attached. You do not need a lot of complicated equipment which is a nuisance to carry around and I would advise you to invest your money in good quality brushes and paint before even thinking about an easel. Then buy one that is sturdy and easy to assemble.

Watercolour paper as we have seen has a light-reflecting surface so if you are out in bright sun this whiteness glaring back at you can be a problem. Wear a big hat! The hat will cast a shadow on to the paper and make it much easier for you to work because, as well as the discomfort of looking at very white paper, it is also difficult to judge colour when looking from this sort of surface back to your palette. The hat will also stop you getting sunburnt, which can obviously be a risk if you are sitting outside in the sun for any length of time.

Working in the sunshine is lovely, but even the most idyllic conditions are not unchanging and during a day's painting the position of the sun will

alter, casting shadows and changing colours. If you work too long on a painting outside, these changes can be confusing and you must get fixed in your mind the effect you want to create, and not try to change shadows part-way through the picture. I would suggest that if you have a day's painting you work on one picture in the morning and another in the afternoon and if they are not completed go back to them another day at the same time of day. Monet painted several series of paintings in which he examined the same subject but at different times of the year and at different times of the day; he would work on several canvases simultaneously. As you do more painting, you will work more quickly and be able to put down more information before things change and this will enable you to capture how the garden looked at a particular time.

The illustrations overleaf show how I set about working on a painting. I have painted directly without any preliminary drawing but if you feel you need to make some pencil marks to guide you that is fine. Do whatever makes you feel most confident, but keep the lines to a minimum.

The first thing I put in was the low hedge, which I felt was very important to the composition. I had chosen to place it off-centre, immediately defining how much foreground and background would show. Next I put in the stems of the vertical hollyhocks, the lines of the tops of the walls and the plant supports on the right. I then moved to the foreground and put in the cabbages, and in the middle-distance painted the shapes of the pink flowers and the yellow hollyhocks.

In the next illustration, you will see that I have painted in the sky using Cerulean and Manganese Blue. I have painted it in below the level I know the trees will be because I want to see the colour coming through the trees when I put them in. I then built up the middle-distance with more green, particularly around the hollyhocks, picking them out. As the picture progressed, I moved from side to side and from the foreground to the background and then forwards again, so I was constantly aware of what was happening all over the painting and not just one area. Think of a painting as something elastic that can be pulled, not only in two dimensions but from side to side and from front to back; each time you put a colour down you are stretching your picture one way or another. This way you see the whole painting taking shape in front of you.

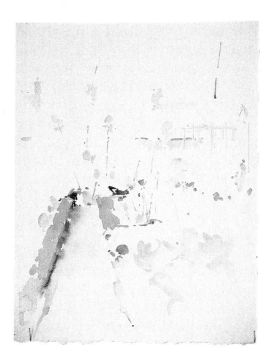

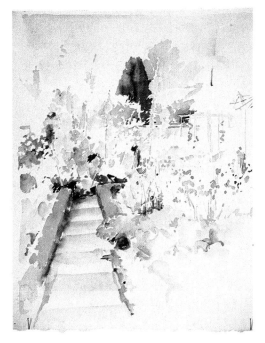
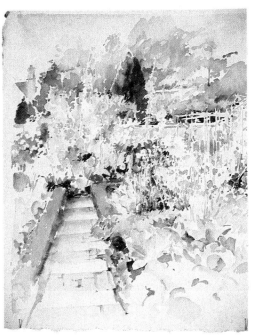

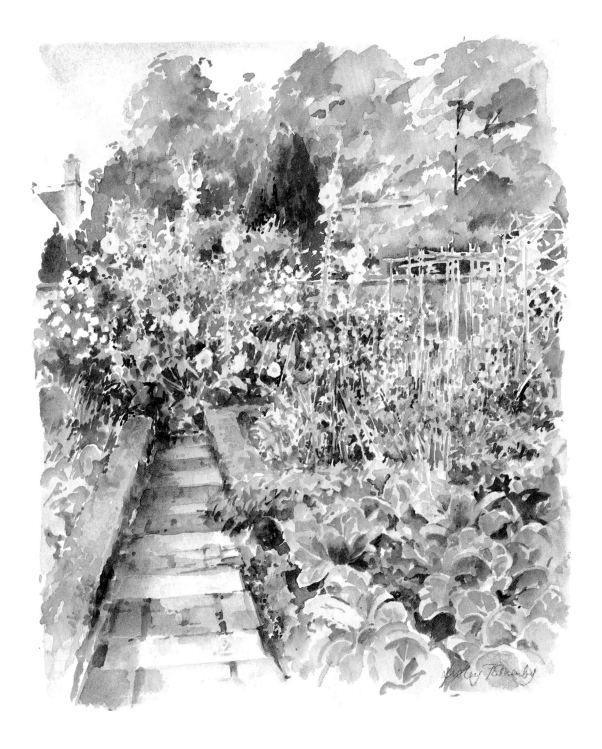

How Plants Grow

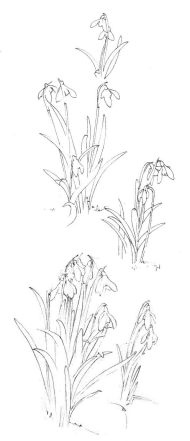

Every plant is distinctive in the way it grows, as well as in its colour and texture. It is important to understand the basic structure of a plant in order to capture its character and so be able to juxtapose it successfully with other plants and elements of the garden. Quick sketches will help to familiarize you with plants. These snowdrop drawings, for instance, had to be done rapidly because it was so cold! As you can see I have concentrated on just the outline, recording the shapes of the leaves, how they grew from the earth, what size they were in relation to each other, and how the heads of the flowers hung. You can get detail of plants if you put them in a vase but you need to see them growing to get the information you need for a garden painting.

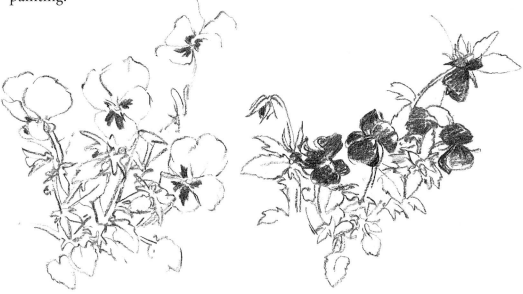

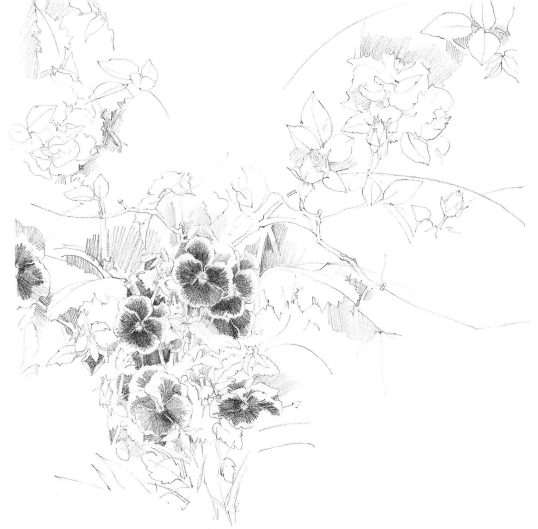

What You Can Find Out

The charcoal sketches of pansies were also done quickly but you can see how it is possible with just a few lines to convey a lot of facts about how the plant grows. We can tell that instead of the leaves growing straight from the earth as snowdrop leaves do, pansy leaves branch from the stems and are dicotyledon as opposed to monocotyledon. The flowers and buds are held in a particular way and we can also show that. The rather more detailed drawing above was done in preparation for a painting, and here I have tried to show what pansies look like when they are growing alongside another plant, a rose, and how the shapes of the two contrast.

We tend to look at a subject and think about its outline when starting to draw, and it can be terribly frustrating when, after carefully outlining a leaf, you find its position bears no relationship to any other part of the plant. The temptation is to rub it out, but this will mean starting again from scratch, and in all likelihood you will only make the same mistake again. Forget about the rubber. What you need to do is look at your subject, and gather all the information about it you can. One of the most useful pieces of advice I was given when I was training was to look at what I was drawing or painting for longer than I looked at my paper or canvas: sometimes we get so tied up in the process of committing something to paper that we neglect to really look at our subject!

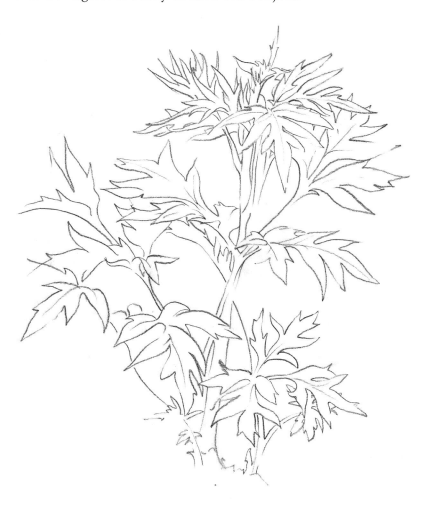

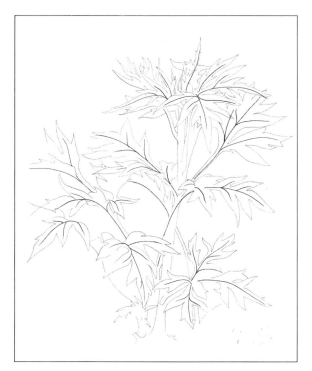 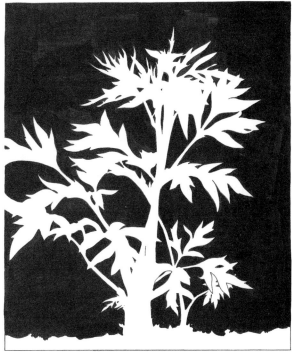

This Conté drawing of a peony plant, opposite, is a quite straightfor-ward outline sketch but it does have some complicated elements: namely that the leaves are dissected, and some are pointing towards us, which is difficult to convey on paper. It is essential, therefore, to look at how all the parts of the plant fit together and relate to each other in order to get every-thing in the right position. The two diagrams above show what you can look for both inside and around the plant. In fig 1, I have emphasized the veins of the leaves, which give you the 'skeleton' of the plant on which to place the full leaves. See, in particular, how useful the lines are in giving the position of the leaves which are pointing towards us. Fig 2 shows the silhouette of the peony. The background is black to emphasize the shapes created when leaves and stems intermingle and cross. Look at the black triangle on the right of the main stem, showing us the exact angle at which the other stem should cross, and where to position the bottom leaf. If you look for these negative shapes as well as the positive outlines, you will have twice as much information.

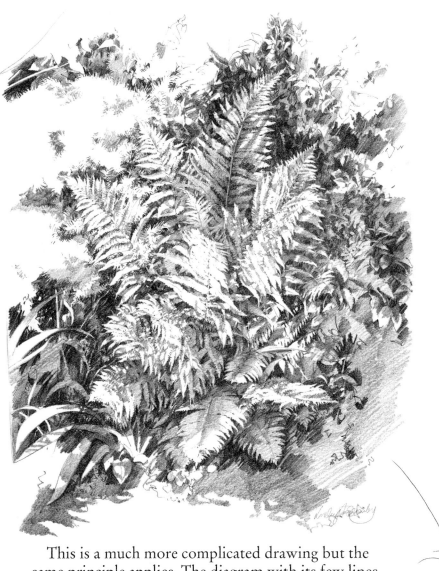

This is a much more complicated drawing but the
same principle applies. The diagram with its few lines
told me the structure of the fern and where all the
leaves should be positioned.

Try these exercises:

(1) Put two chairs in front of you, in any position,
so you can see all eight legs, make an outline drawing.
In a couple of vases put a variety of branches and
leaves, not too many, making sure you can see some

empty spaces, and place the vases on the floor in front of the chairs so that the chair-legs form shapes behind the vases. Make a drawing of the vases and their contents on top of the one you have already done.

(2) With a 6B pencil lightly shade in a piece of cartridge paper. Look at the still-life you have already set up and, with a rubber (a plastic one is good for this), draw in the shapes between the objects in front of you. Slowly the objects themselves will appear.

Both these exercises will help you to really look and see new ways of tackling a drawing, as well as being good practice for when you tackle plants growing in front of and around things in the garden.

Making Colour Notes

Gathering information can be an enjoyable exercise in itself. Although you will not use all the preliminary sketches you make, this doesn't mean they haven't been useful. Even if a drawing hasn't worked as you would have wished, you have still had to observe your subject very closely, and from this you will have gained invaluable information. Many of my students, even the ones who are experienced botanists, express surprise when they spend time really concentrating on the structure of their subject; this is because we seldom stare at an object for two hours on end, and so, although we think we know what something is like, there are a lot of things we just don't notice. We have looked at ways of making preliminary studies to help with composition and the next step is to gather information about the colours of your subject.

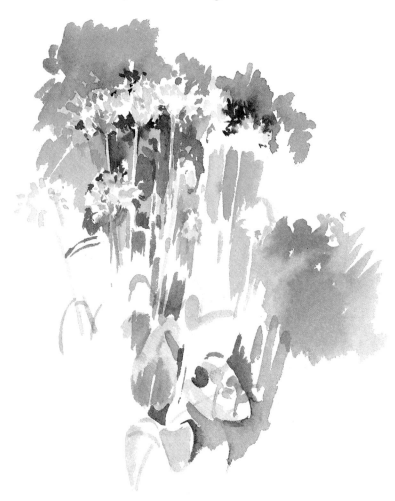

We have seen how the colours of plants and gardens change with the time of year, but it is also important to note how the colours also differ with the time of day and weather.

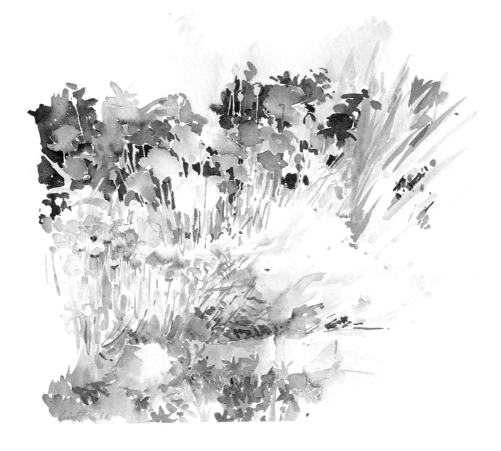

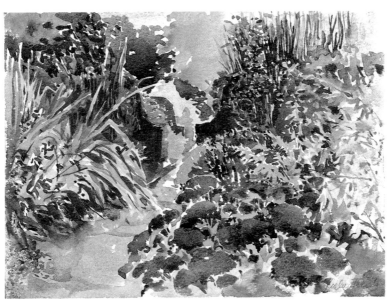

Make a quick sketch, or make some notes, so you can remember the differences of texture and mood.

The painting of yellow primulas, on page 50, was done very speedily in bright sunlight. In fact a lot of the yellow was bleached out by the sun, and, as you can see, I have left some white paper showing to illustrate this. I have noted the colour of the leaves, a bluish green, their shape, and the fact that shadows were falling, making patterns on them. It is a record not only of the structure of the plant but also of what it looked like as it grew in a particular place at a very particular time – half an hour later it may have appeared very differently. The sedum plants at the bottom of page 51 were blooming in autumn, when I visited Newby Hall. It was also very cold, and I was perched on the corner of a low fountain basin – so I tried to complete my painting as quickly as possible! Many of the greens in the picture are quite muted, because I have used Burnt Sienna in the mixes, and this warm brown is echoed in the orange leaves and plants. The sedums in the foreground were painted using Alizarin Crimson,* and the coldness of the day I have tried to convey with cool, light blues in the border and background.

The poppies were one of a series of studies I made before completing the final painting on the title page. It was a very hot sunny day and I was particularly interested in how the poppy flowers stood out from the very dark shadows, which were cast behind them.

For none of these sketches did I use pencil. I wanted to put onto paper, as quickly as possible, the combination of colours that would interpret my feelings about the place at that particular time of day and year.

*Compare this colour with Permanent Rose on page 58.

Colour

The basic palette will give you most of the colours that you will need as you start to paint. However, as with the different greens available as we looked at on pages 18–19, I am now going to describe some other colours you may also like to use.

Permanent Rose: This is a cool clear pink and you might think that there is very little difference between it and a dilute Alizarin Crimson, but this is not the case. Alizarin Crimson is a much denser, richer colour, which becomes immediately apparent when you look at them both mixed with blue (in this case Ultramarine). Crimson gives the sort of colour you might need for a peony or a hellebore, but it will not give the clear, almost transparent mauves and blue/mauves which you need so often when painting flowers. For example, just a touch of Permanent Rose combined with Ultramarine will give the colour of bluebells. You will find that the colour is an essential addition to the palette of garden painters.

Rose Dore: unusual delicate pink, warmer than Permanent Rose

Scarlet Lake: brilliant red, which when diluted also gives a delicate pink

Light Red: soft warm colour, like terracotta

Indian Red: much denser red/brown pigment

Raw Umber: clear ochre, like Burnt Sienna in consistency, but more yellowy/brown

Davy's Grey: lovely, clear pigment; a good mixer too

Manganese Blue: clear blue, which has precipitating qualities and so gives unusual and unpredictable effects, for instance, separating out when mixed with another colour

You will have noticed that I refer to certain colours being transparent or dense. This may seem odd when we know that watercolour paint must be

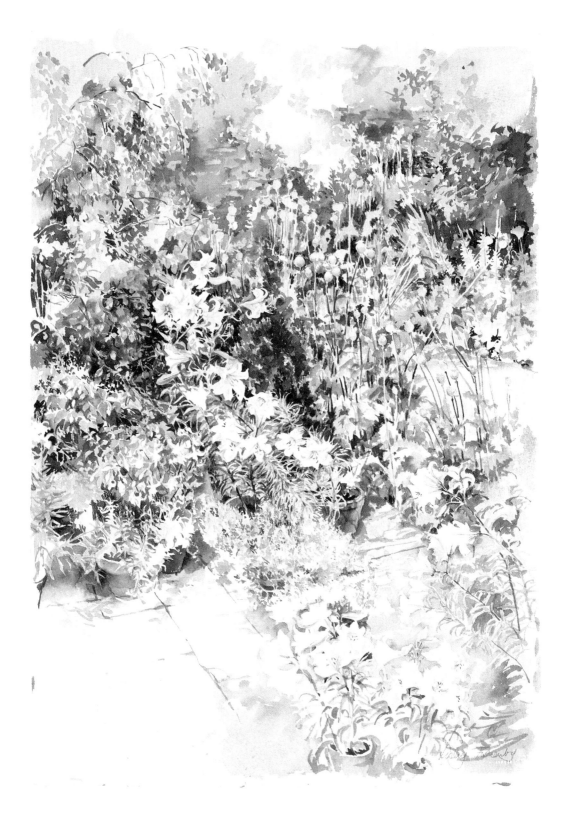

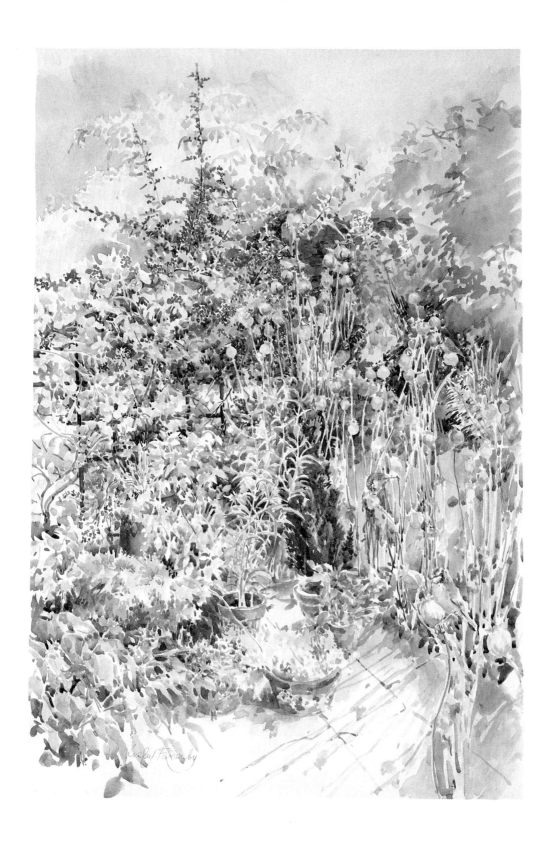

transparent, but particular pigments have special characteristics and so we can say that they are relatively transparent or opaque. Discovering these peculiarities is one of the pleasures of painting in this medium.

Prussian Blue and Ultramarine are two intense blues; but, whereas Prussian Blue is translucent and shiny, particularly when diluted, Ultramarine is far denser and can even be quite grainy when applied to the paper. Raw Sienna is a strong, transparent colour, which reflects the light well. It is good for using as a wash under earth colours, giving light and warmth, or as a thin wash or glaze over other colours. It is a useful trait of watercolour painting that you can modify a colour on your paper by washing another colour over it. Lemon Yellow is not so transparent and so not so suitable as a glaze; in fact if you use it straight from the tube you will find you can almost cover a deeper colour with it.

It is important to be aware of the different *densities* of colour as well as thinking about the colour itself. If you were painting a pool in the sunlight, colours like Prussian Blue and Viridian would be better than say Ultramarine, but for the strong striking colour of a pot of lobelia, Ultramarine would be the best colour.

Seasonal Colour

The colours of plants change subtly with the seasons. The two paintings on pages 54 and 55 of part of our garden were painted within a couple of months of each other, the first in July, the second in September.

Although the plants are the same, the lily flowers have died by September, and the berries on the cotoneaster are showing. But notice, too, that the greens are cooler in the first picture – the poppy pods are almost blue – and I have used the colder yellows, Lemon and Aureolin, more than the Cadmium Yellows. In the second painting, the greens are much denser and contain more of the warmer yellows and the earth colours, like Raw Sienna. The small conifer is the same colour in both pictures and so you can see how the changing colours contrast with it. I have also used differ-ent blues to indicate the change in season. Of the four blues we are now

familiar with, I have used more of the lighter Cerulean and Cobalt in the first picture, and more of the deeper Prussian and Ultramarine in the second.

The poppy pods have turned brown in the second painting (Burnt Sienna and Yellow Ochre), and these pick up the browns of the terracotta pots (Burnt Sienna and Light Red); the pots are far more dominant in this painting, mostly because their colour is reflected through the rest of the picture.

Shadows play an important part in both compositions. I have used a mauvish colour. On strongly coloured surfaces, for instance lawns, the shadow will be a darker shade of the same colour, i.e. a dark green, but on neutral surfaces, the shadows can be different, complementary colours of the light that is casting them. Lemon light will give mauve shadows; orange light will give bluish shadows, and in red light the shadows are greenish. Look at the colour wheel on page 15.

Each element of your painting may cast different shadows, and if you portray these, your painting will be especially individual. Note, for instance, that colour can also be reflected into shadows from the object which is casting the shadow. Put a lemon on to a red cloth and see what happens to the colour of the cloth, and vice versa. The possibilities are endless!

Notes for page 58
A thin wash of Prussian Blue was left to dry and then partially painted over with Raw Sienna and Lemon Yellow. Both these colours modify the blue showing how colours can be changed after they have been applied to the paper. You can also see the different qualities of the over-laying pigments; Raw Sienna is more transparent than Lemon Yellow, which at its thickest nearly obliterates the blue.

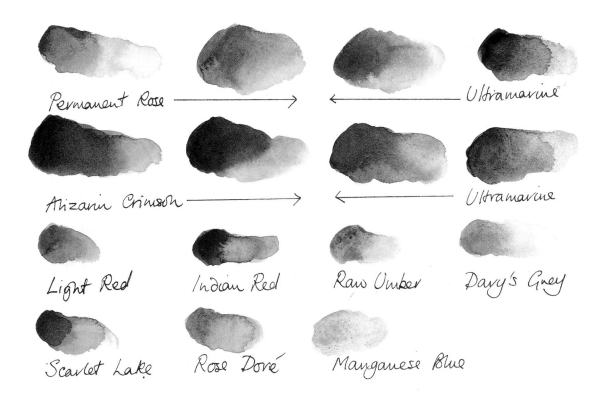

Permanent Rose ⟶ ⟵ Ultramarine

Alizarin Crimson ⟶ ⟵ Ultramarine

Light Red Indian Red Raw Umber Davy's Grey

Scarlet Lake Rose Doré Manganese Blue

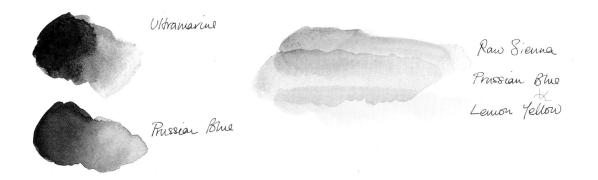

Ultramarine

Prussian Blue

Raw Sienna
Prussian Blue
+
Lemon Yellow

Ellipses

Most flowers seem very complicated to draw until we take time to look at them individually and discover their structure. Once we have seen that many flowers fit within a circle, or, when viewed from different angles, within ellipses (flattened circles), things become simpler.

When I was a student, I attended a lettering class for a term, where we drew and then painted the Trajan Roman alphabet. To this end, we practised drawing circles very precisely. Although you do not need to draw perfect circles for flower heads, the method we used is very helpful.

Using a ruler, draw a square, then draw in two lines diagonally from corner to corner and two joining the centre points of each of the four sides. Starting at one of the points where a line meets a side of the square, draw a curved line across the diagonal to the next meeting-place of a line with the square. Continue linking each quarter section until you have drawn a circle.

Take a plate, and hold it in front of you so that your eyes are level with its centre. This is the shape you have just drawn. Now tilt the plate away from you slightly and you no longer see a circle, but an ellipse: the horizontal dimension of the

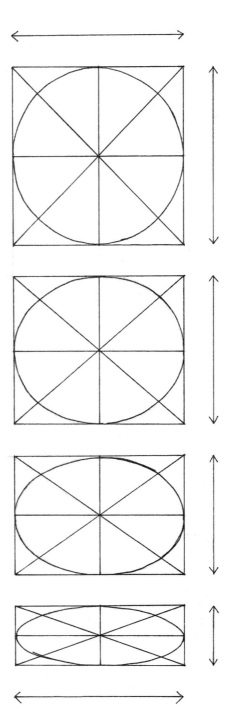

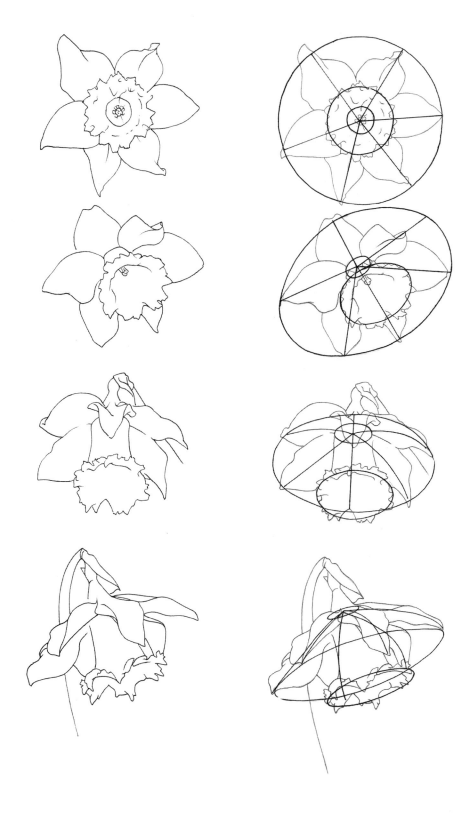

plate remains the same but the verticle dimension has shrunk, which is also what you see when a flower is tilted to the side. Look at the many different angles as a circle tilts further and further away from you, as the upright line within the square gets shorter and shorter. On each side of this upright line, the curve making up the ellipse is a mirror image of the other, as are the curving lines above and below the horizontal – this will help you to judge whether your drawing is correct.

Try some of these shapes freehand now, not in the way you have just tried, which was slow and careful, but by drawing long, free strokes. If you do not get them right first time, do not rub out the part that is wrong, but use it as a guide so that you can modify the shape as you go along.

Daffodils are complex flowers to draw because they are, in effect, made up of three circles. The diagonal lines on page 60 show how the circles relate to each other, and what happens to the ellipses as the flowerheads are viewed from different angles. The lines show the position of the six petals. To plot the position of petals in any flower, work from the centre out (like the spokes of a wheel). If you have the central line of the petal, you can then judge whether the other petals are in the right position as you draw, starting at the tip of one petal and drawing the outline of the whole flower until you get back to your original point. Look at the outer circle as it changes. The central point of the flower doesn't always stay in the centre of the ellipse. Instead it moves upwards, because we see the petals nearest to us as more foreshortened than the ones further away. It is not necessary to put all these lines in when you start your drawing, although the ones for the centre of the petals can be useful if put in lightly.

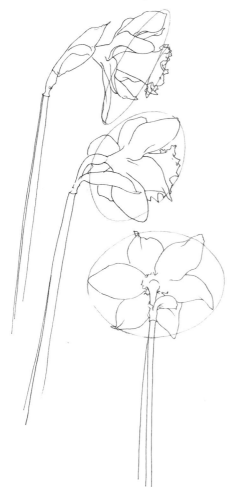

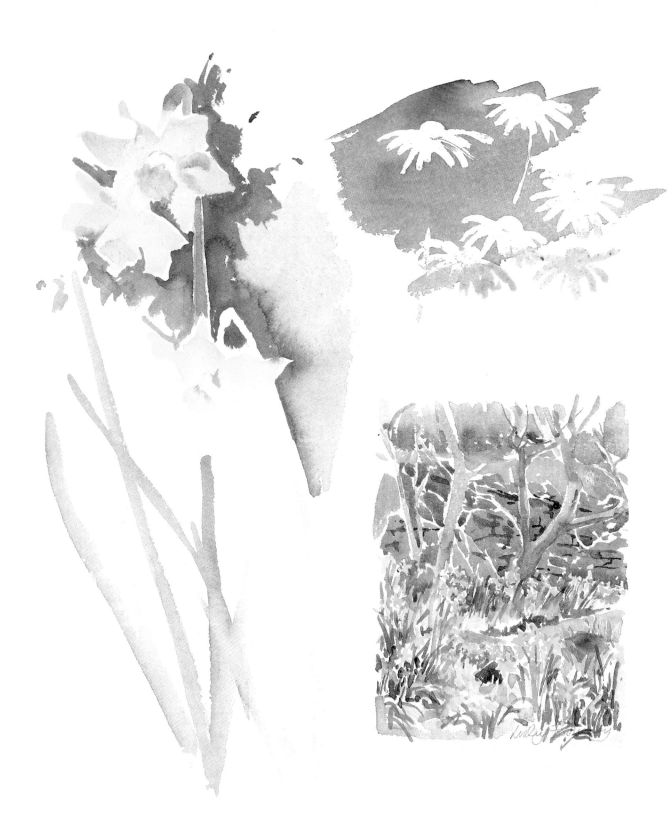

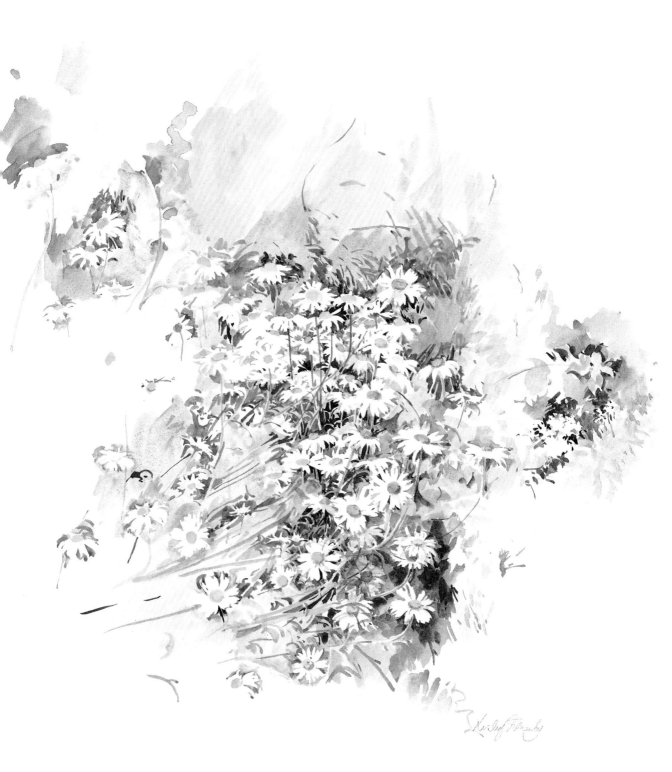

Positive and Negative Shapes

White flowers can be a problem to paint in watercolour because we cannot use white paint: the paper has to be left unpainted and the background is coloured to show up the shapes of the flowers. If you think back to the exercises on pages 47–49, you will remember how we looked at negative shapes when we were drawing. The same principles apply to a painting. We look for the shapes *between* the flowers to give us their outline. The partly completed watercolour of daisies on page 63 demonstrates this.

On the left side of the picture, you can see how I started positioning the flowers by painting in just the yellow centres. As with the daffodil drawings, once the centre has been drawn, it is easier to build up the rest of the flower. I used dilute watercolour wash to begin the general background away from the silhouette of the daisy. In my mind I worked out where the circles and ellipses would fall. Then I put in some lines for the stems and, using less diluted watercolour, continued the background, drawing in closer towards the flowers. I was confident enough now to takes 'bites' out of my white shapes and form the petals. The part of the painting around the terracotta pot is the most complete, where I worked detail into the negative shapes between the flowers, and made a stronger contrast with the white to reveal the positive shapes. I was

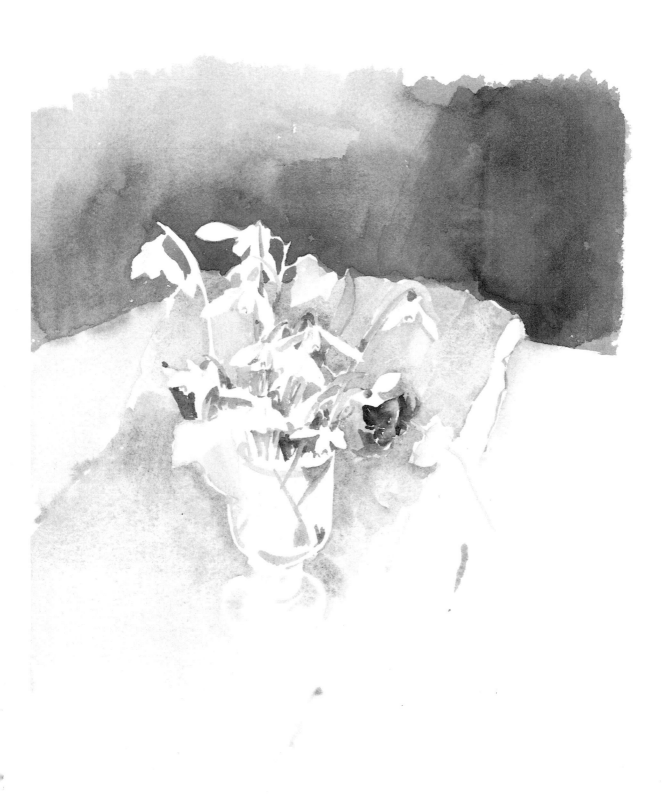

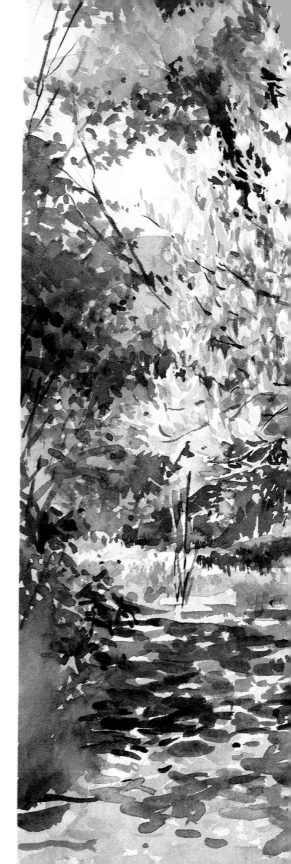

careful to vary the tone of the paint surrounding not only the different flowers, but also the different parts of the flowers, so that the effect achieved is that of some flowers almost disappearing into the background, and other more dominant flowers in quite stark relief. Finally, I put in some shadows to achieve even more depth, and to convey the strong sunlight and heat of the day when I was painting.

Masking fluid can be used if you want to block out an area that is to be left white. When it has dried, it will be resistant to paint. To remove it, just rub it off with your finger or with a rubber.

NB Test it on your paper before using it on a painting to ensure it doesn't affect the surface of your paper, and never use it on damp paper. I do not use resist mediums such as this because I find it can interrupt the rhythm of my painting. I prefer to see the flowers emerge from the background, like in the painting on page 65 of snowdrops.

Put a few white flowers into a container and place them against a strongly coloured background. Now make a line drawing, not of the snowdrops but of the shapes around and between them. On another piece of watercolour paper, with your first drawing to guide you and still looking at the flowers, paint in the background and then any leaves – what you will be left with are the white flowers.

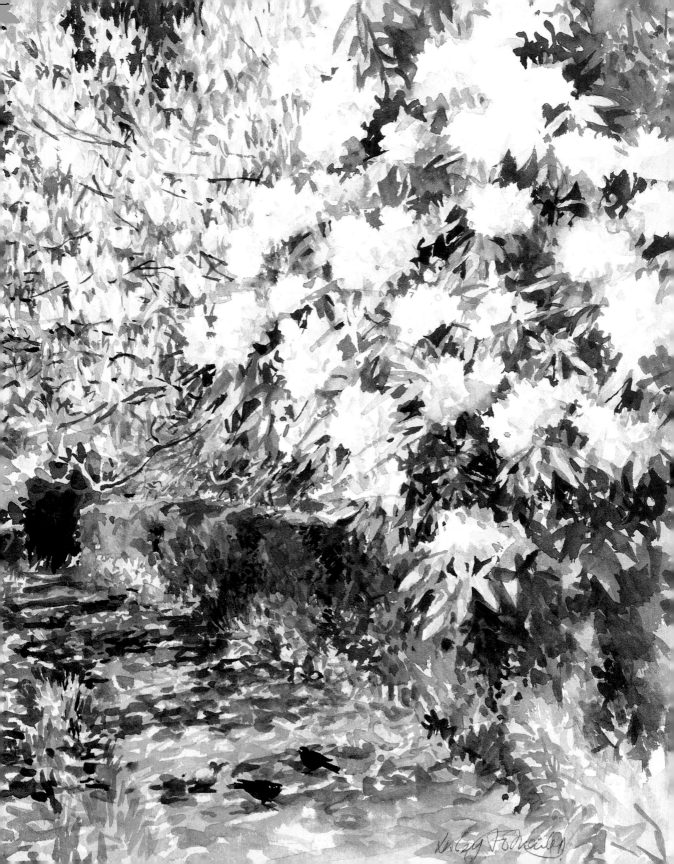

Scale and Perspective

We know that objects appear larger the closer they are to us, and become proportionately smaller the further away they are. Often, though, when we compare relative sizes the extent of this difference in size can be surprising.

The drawing, opposite, shows a terraced garden with a house in the background. I sat on the lower lawn in front of a rose bush looking up towards the house. The rose was so close to me that its diameter appeared to be about one-and-a-half times the length of the whole window. This apparently amazing change in scale is what gives us the feeling of space within the picture, and without it we would have no clues as to distances as there are no paths, steps or lawns to guide us.

To compare the size of one object with another, take a pencil in your hand and stretch your arm out in front of you, making sure your elbow is not bent. Bend your hand up at the wrist so that the pencil is held

vertically in front of your eyes; the top should be at about eye level. Look across the room and choose an object to measure, for instance a mug on a table. Close one eye so you can focus on your pencil and the mug at the same time, and line up the top of the pencil with the top of the mug. Slide your thumb down the pencil until its tip is at the bottom of the mug. You will now have a measurement that you can compare with anything else in the room, so, keeping your arm outstretched and thumb in position, swing the pencil across the room and line it up with another object either closer to you than the mug or further away. This is what I did to compare the rose with the window. I must emphasize that it is very important to keep your arm fully stretched; if you bend it at all then the distance between your eye and the pencil changes and your measurement is no

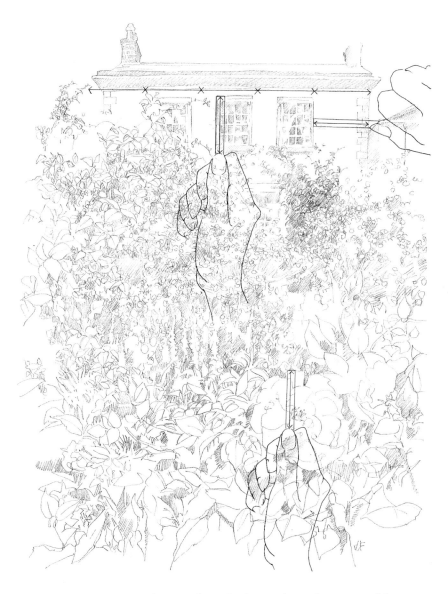

longer consistent. Once I knew the window's length, I was able to compare it with things other than the rose, and to use it not just on a vertical plane but also horizontally. For instance, to compare its measurement with the overall width of the house, I kept my arm outstretched and the pencil in position, but turned my wrist through a ninety degree angle to my left, and by moving the pencil across the house I could see it was nearly five times

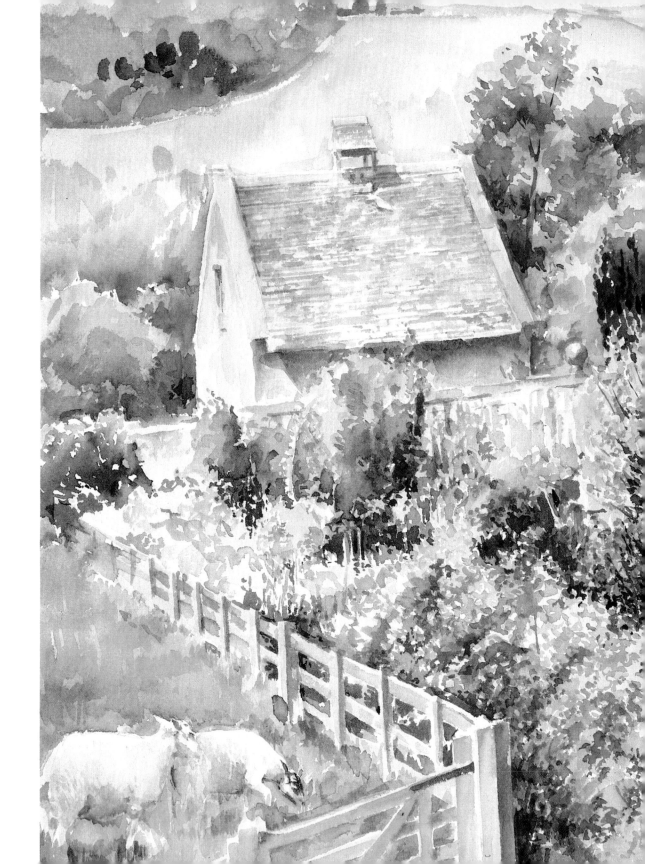

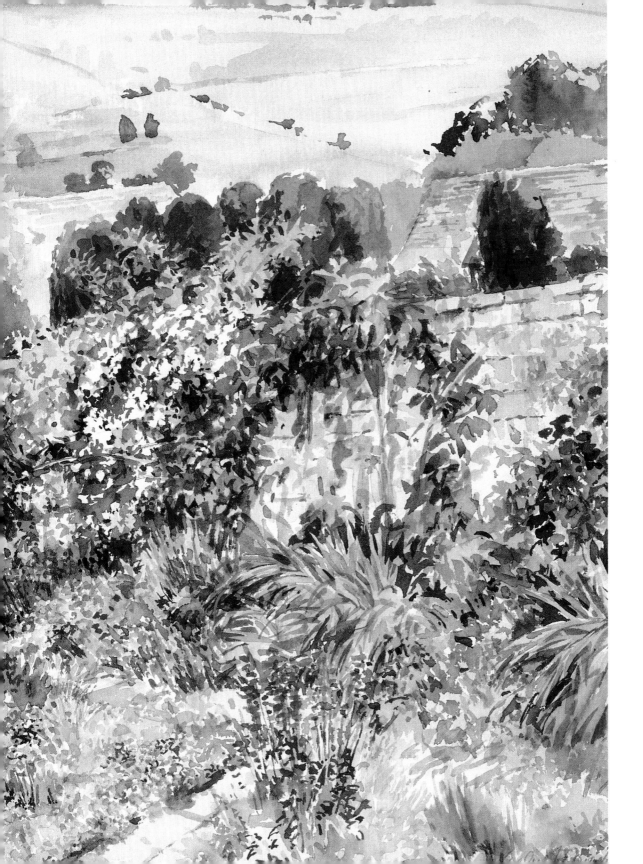

the length of the window. In this instance, I did not need to check the relative sizes of the window and façade because they are on the same plane; I was checking to see that my proportions of the building were accurate.

The drawing on page 69 is an interesting view of a garden, but a very straightforward one, as we do not see the side walls of the main building so we are untroubled by perspective. The only distortions are the foreshortening of the roof and the sides of the chimney stacks getting smaller, as they go further away from us. Things are not always so easy! If you want to paint a garden with paths, hedges, walls or buildings set at an angle to your line of vision then you need to consider perspective.

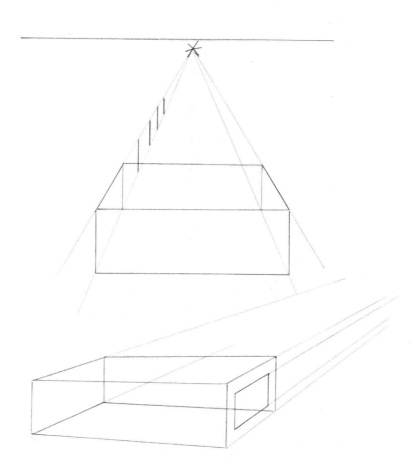

If you see two parallel lines passing directly in front of your line of vision then they will continue on their parallel course for ever, never converging. Once you move and look along them to see where they are headed, then they will gradually appear to become closer together until they converge at a 'vanishing point'. Take a box, a shoe box is good for this, and hold it out in front of you so that you can see a little of the inside; you will be able to see the entire length of the back of the box and some of the two sides (which are parallel, of course). The two sides are converging and the back of the box appears smaller than the front because it is a measurement of the distance between the two sides of the box as they get closer together.

If you look at the four vertical lines, which join the corners of the box, you will see that they remain upright, at ninety degrees to the ground, whatever happens to the height of these lines (they get shorter in the distance) they always stay at the same angle. In the painting on pages 70–71, entitled *The Garden at Snowshill*, I have painted a fence which recedes into the distance. Notice how the lines of the top and bottom of the fence gradually converge and look at the upright stakes; they all remain parallel to the sides of the paper but appear closer together the further away they get. This illusion is also apparent in the picture *Evening Primroses at Barnsley House*, right, where the trees are in fact the same distance apart from each other but they appear to get closer the further down the path we look.

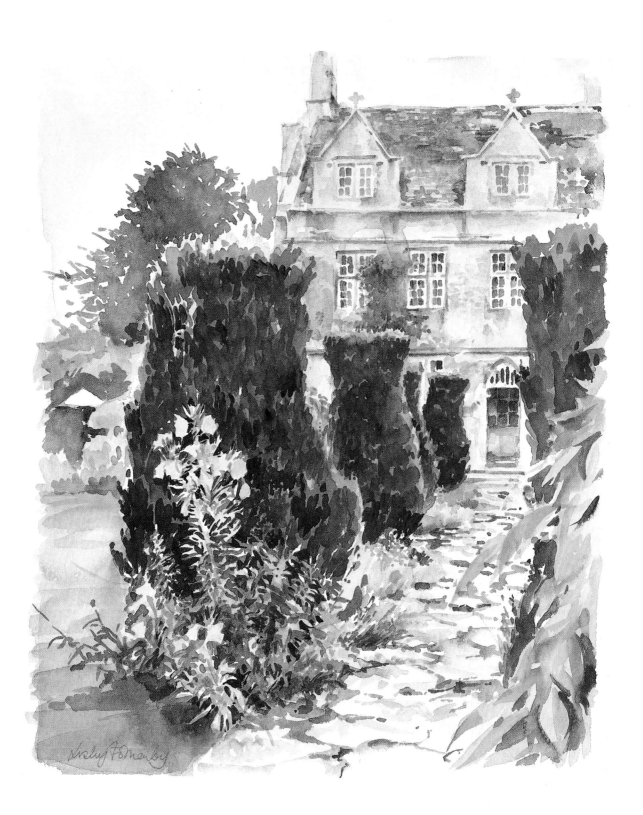

The painting of Snowshill contains the fence disappearing from us, and a wall and a path that follow a different direction. The wall is parallel to the fence, so their lines converge at the same vanishing point. I have shown them in this diagram as well as indicating where the vanishing point of the path would be.

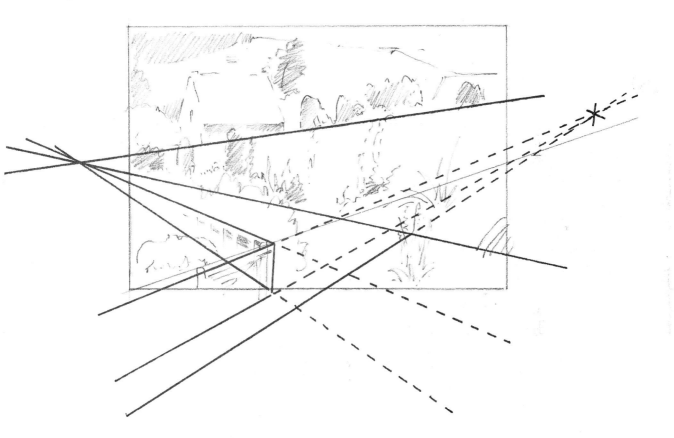

Knowing the rules of perspective is very useful and I have shown how they apply in these paintings in order to make sense of what can be a confusing subject. However, I would not advise you to actually draw in any of these lines when you are starting a picture or you will end up with hard, rigid edges where you may want just an indication of what is happening. When I started painting the wall at Snowshill I put in a series of short lines and dots for guidance, but I also left some spaces so that I

would have room for the foliage pouring over the wall. If you want to
make a note of lines and vanishing points, put them on a preliminary
sketch. Too rigid an adherence to what you expect to be happening can
also blind you to what is actually there; the fence and wall at Snowshill not
only disappear off to the left but they follow a slight downward slope,
which affects the angles of all the lines. In order to check what is actually
there, you can use a variation of the device mentioned on page 68. Take
your pencil and, with your arm stretched out in front of you, turn your
hand until the shank of the pencil is lying along the line you want to gauge,
which will isolate the line, and make it easier to judge the angle when you
are painting or drawing it.

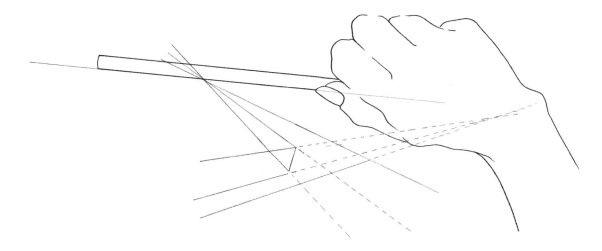

Light and Shadow

How we see everything around us is dependent on light. You only have to watch a landscape or a garden in bright sunlight to see the transformation when a cloud passes in front of the sun to understand what effects changes in the type of light and the direction of that light can have.

Strong sunlight from one particular direction, which casts well-defined shadows, can completely alter a very simple view and allow you to see all sorts of new shapes within it. The charcoal drawing, below, has a very straightforward composition: a path leading through an archway in a hedge, to more hedges beyond. See how the light creates the odd distribution of shapes, picking out certain things and casting others into shade. Look at how the light has shown up the wedge shape of the hedge in the background, which joins with the L-shaped patch of light on the grass in

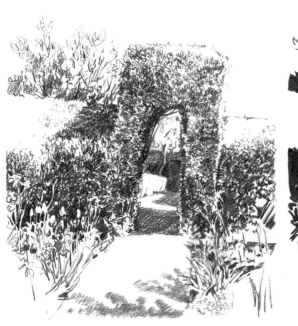

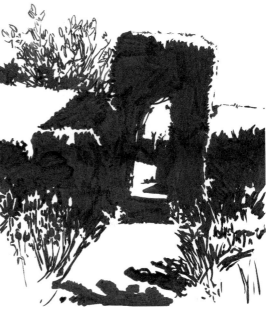

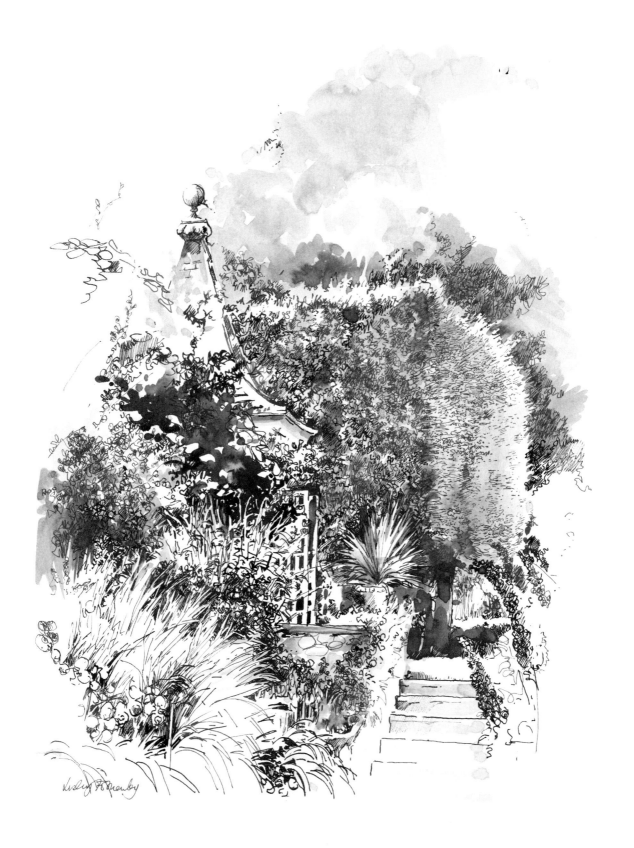

front of it to create a completely new shape. I have simplified the drawing in the diagram next to it to further illustrate how the light changes this view. I eliminated textures that were picked out in the drawing and reduced the half-tones so that they became either black or white (no greys). If you want to do this for yourself when you are looking at a garden, half-close your eyes and look at what you want to paint. You will not cut out all the half-tones, but you will eliminate a lot of the texture and be less aware of the colours, as we did on page 17 when we were discussing tone. Try to think of what is in front of you not as just a collection of things you are familiar with but as an abstract pattern of new shapes.

The pen and ink drawing of Hidcote, opposite, was done in less intense sunlight but we can still see how the direction of the light (from the right) has given form to the trees in the background. The plant in the pot at the top of the steps is illuminated and is a focus for our eyes as we look through the picture; we stop to look at the plant and then move around it to discover the texture of the plants in the border and the patterns made by the panes of glass in the door beyond. Also picked out are the tops of the trees giving them almost a halo of light. This is a phenomenon which often occurs when something is lit from above and is particularly noticeable when the edge that is illuminated is not hard but uneven and broken, like the ends of the branches of these trees. You may also have noticed it around people's heads if they are sitting under a window.

The type of light also influences how we see a view. In the evening light we are less aware of strong colours, and tones tend to be closer. This is why in such conditions white flowers become very prominent in sharp contrast to the effect in the daylight, the colours of others merging with each other and with the foliage which may be of a similar tone. Colours are cooler and shadows not so strong. Yellow light casts a purplish shadow (its complementary colour), red light a greenish shadow and orange light a bluish shadow. I must emphasize that it is important not to use black pigment in your mix when painting a shadow, otherwise the colour will appear dead and not look as if it has any connection with the objects around it that are casting the shadows. On page 82, there are some combinations of colours which you may find useful when painting shadows.

As we saw in the drawings of the path and the hedges, shadows make all sorts of new patterns over an area of garden and can help you compose an

interesting picture. Sometimes they are cast on to a flat surface as in this brush and ink drawing of a magnolia tree by a path; other times they are distorted by being projected on to more than one plane. The drawing of steps opposite the Contents page illustrates what happens to the shadow of a lupin leaf when it is cast on to the vertical and horizontal planes of a step. Try this exercise for yourself. On a brightly lit window-ledge, put an

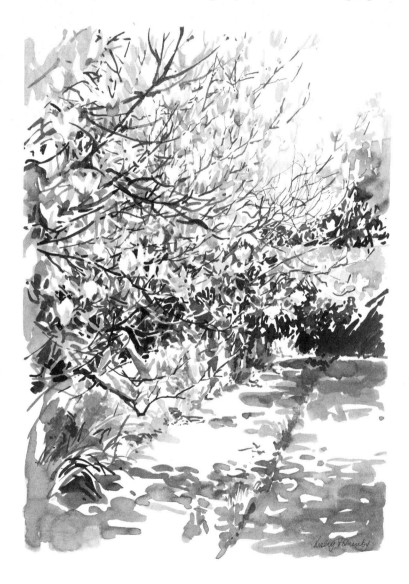

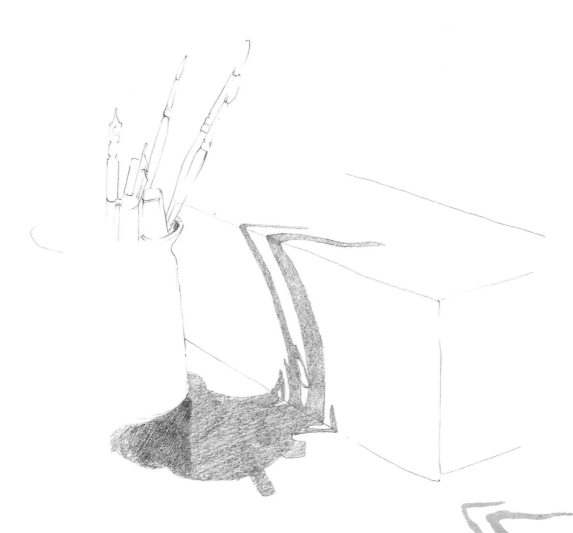

object that will cast an interesting shadow. (I have used a mug with pens and brushes in it.) Next to this place a box (the shoe box again, perhaps), and draw the shadow cast by the first object as it is projected first on the window-ledge and then on the sides of the box. Now try this with paint.

Paintings do not always need strongly contrasting tones to be interesting. Diffuse light, either bright or dim, will illuminate the object more uniformly,

Cerulean/Alizarin Crimson

Cobalt/Alizarin Crimson

Cerulean/Light Red

Cobalt/Light Red

Cerulean/Burnt Umber

Cobalt/Burnt Umber

Ultramarine/Yellow Ochre

Manganese Blue/Light Red

Ultramarine/Sepia

Manganese Blue/Burnt Umber

(see how the colours separate in these last two mixes – this can be a useful effect if you anticipate it will happen)

Viridian/Cadmium Red

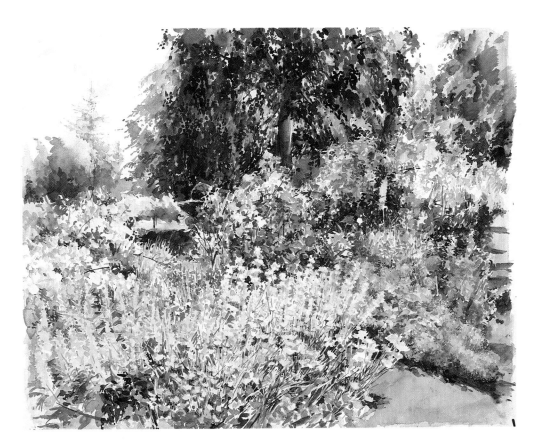

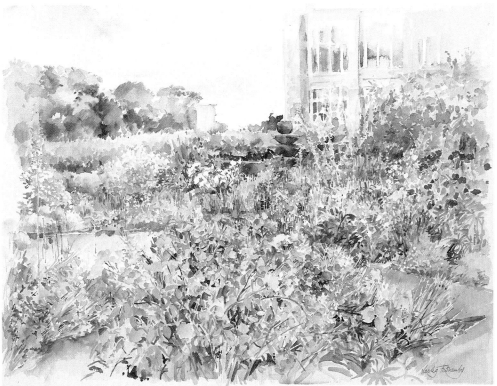

creating a different atmosphere in a picture. The tonal range will be closer, and this limited range can be anywhere within the scale of tones. Look back to page 14 to the examples of colour mixes from light to dark; a painting done in the evening light will be restricted to the tones at the darker end of the range, one executed at midday may be limited to the middle of the range. If you look at the paintings on the previous page, you will see that one has a very wide range of tones and contains strong cast shadows, whereas in the other all the tones are closer.

Both paintings of the same garden were done on blisteringly hot days in June, but from different viewpoints. The first was painted in the mornings of those days when the sun was casting very strong shadows and picking out the top of the hedges (in the distance on the left), and the shapes of the plants against darker backgrounds (the yellow flower head on the right). Although the colours of the plants are softer in the second picture, the main reason it looks so different is the fact that I painted it in the afternoons of the same days; then the same plants are transformed by the softer light (the pinkish, mauve rose bush on the right of each picture is the same species). There are fewer shadows and those that are there are not so strong, and although there is a wide range of colours they are quite similar in tone.

You can understand, I am sure, that it would have been impossible to paint either of these pictures all in one day. I would have been able to get the plants the right shape and in the right place, but not to capture the feeling of the time of day because their colours would have changed as would their relationship to each other, whether they were dominant because they were illuminated, or whether they melted into the background foliage. Just looking at the colour of the grass and the strength of the shadows cast will show you how much changed in just a few hours.

Colour is changed not only when it is darkened by being cast into shadow, but also when it is directly hit by intense light. Sometimes the colour can appear to be almost completely bleached out by the effect of the sun, as we saw in the sketch of primulas on page 50, and greens can change to blues depending on how a leaf is caught by the light. Again, it is important to look for what is there and not just for what you are expecting to see.

Paths, Hedges, Fences and Steps

We have now looked in some detail at perspective and at the effects of light on a garden. Both the use of perspective and an understanding of the help directional light gives us go some of the way to solving the problems of painting and drawing paths, hedges, fences and steps.

When I was painting *Loganberry Canes Over a Pathway* overleaf, I sat in the centre of the path and looked straight ahead. If you want to see for yourself what was happening to the path in front of me, sit in a chair and put a drawing board, or anything large and rectangular, on the floor in front of you. Take two rulers or pencils and, holding one in each hand and with your arms outstretched, line them up with the two outside edges of the board. They will both be pointing slightly inwards, towards each other, and if you could continue the lines they are making they would join at a vanishing point about at your eye level. In the picture only one side of the path can be seen but you have an idea where the centre is because of the line created by the edges of some of the paving slabs, which is at right angles to the bottom edge of the sheet of paper and corresponds to the line of symmetry down the middle of your board. We have created an illusion by deceiving the eye into believing that a path is receding into the distance. This device can be taken a step further by looking at what is happening to the individual slabs of the path. Take your drawing board and prop it up against a chair so that it is facing you. Using the method on page 68, measure its height, its width across the bottom and across the top. Take away the chair and, ensuring that the bottom of the board isn't moved, lay the board back onto the floor and retake your measurements. The width of the bottom of the board won't have changed, of course, because it is in the same place, but the top width will be smaller as we would expect and so is the height (now the length). This last dimension is the important one, because the rectangle is receding into the distance, and so our eyes now see a shorter measurement. If we placed another board of the same size on the

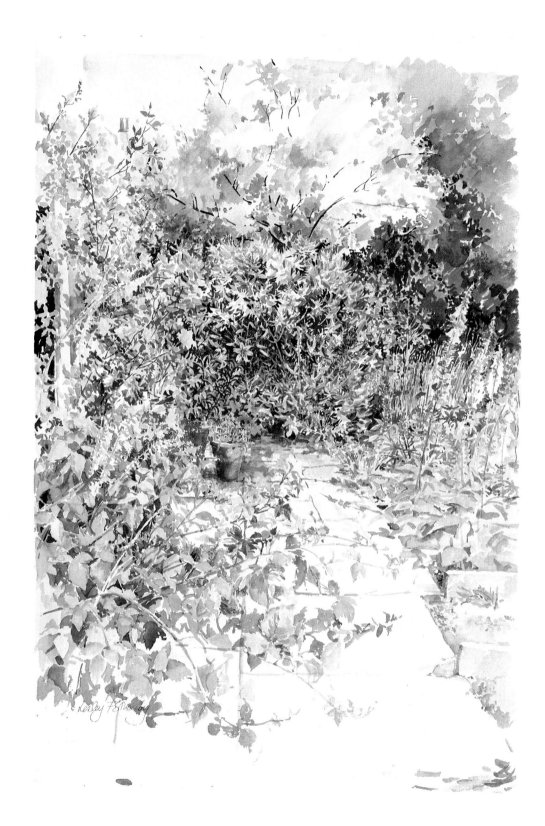

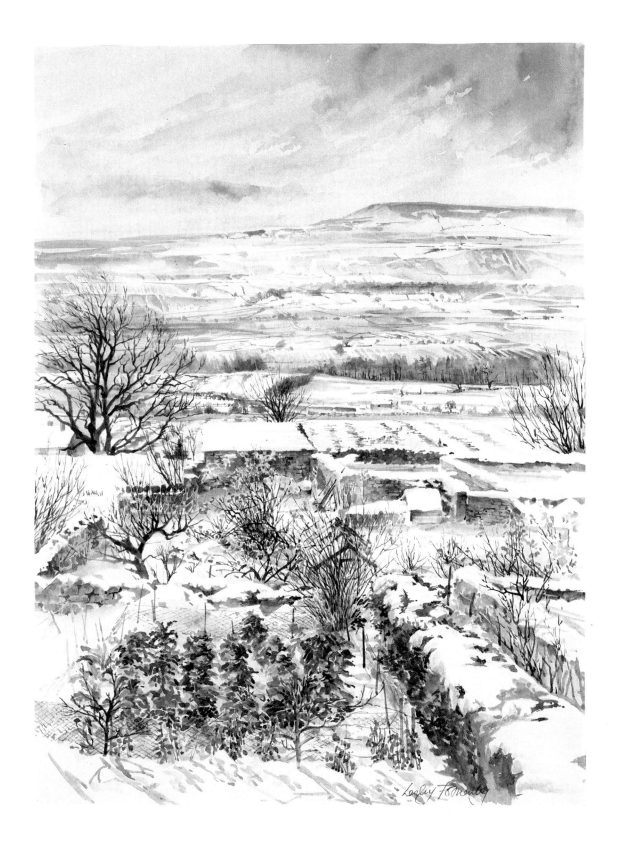

Lesley Fotherby

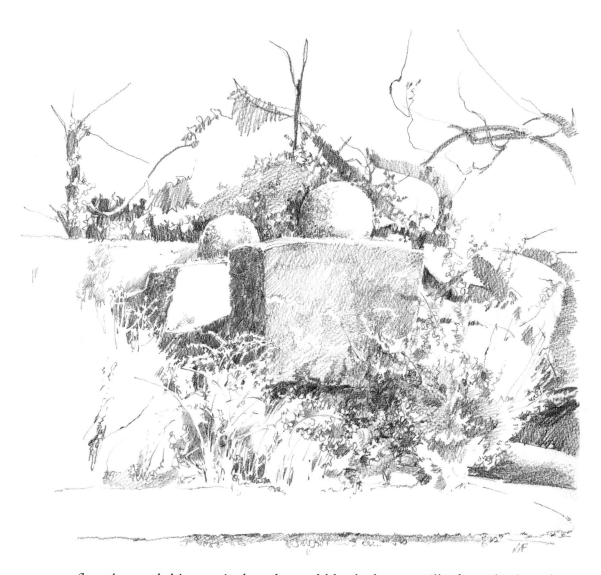

floor beyond this one, its length would look shorter still. If you look at the painting again, you will see that this is what is happening to the paving slabs.

Because I wanted to sit in the centre of the pathway and its line of symmetry (see page 101) is almost in the middle of my paper, I was careful to choose a place along that path which showed lots of variety, making the picture more interesting. The canes of the loganberry interrupt what would have been a rather uninteresting part of the path before our eye is taken

back to discover the orange lily among the dark foliage of the background. Between these two subjects, I placed two plant pots, which further enhance the feeling of distance. They are useful to the composition because of their colour, the powerful reds and terracotta contrasting with the more muted colours in the rest of the picture. They also give focus, rather like a visual jolt, to the painting. Look at the picture, then cover with your fingers the pots and the geraniums to see what I mean.

Sprouts in the Snow on page 87 is a view of the same garden but from an upstairs window. The garden is on many different levels and the walls and hedges that run in almost every direction were accentuated by a covering of snow. From my vantage, I therefore had the unusual view of the tops of these hedges and walls and I was interested to paint them because of the patterns their uncovered sides made on the white landscape. There are shadows in this painting but I did not have to rely on strong directional light to pick out solid shapes as the snow did this for me.

In the drawing of a topiary hedge, opposite, we can see that the light is illuminating the top of the hedge and its right-hand planes. The left side is in the greatest shade whereas the side nearest to us is in partial shade, and so it is easy to work out which direction the light is coming from. Try this for yourself. Take a shoe box and place it by a window in a position where you can see three of its planes. With a soft pencil, make a drawing of the box, leaving the top white. Shade in the two sides and you will see that it immediately becomes a three-dimensional object. The lines you first drew disappear, and you are only aware of the area where the tone changes.

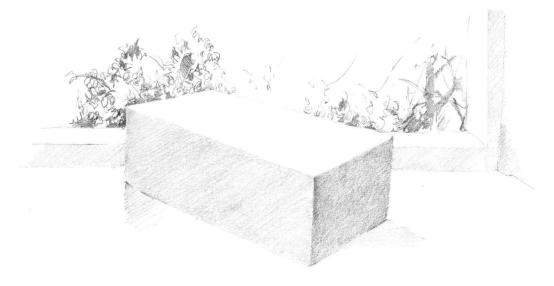

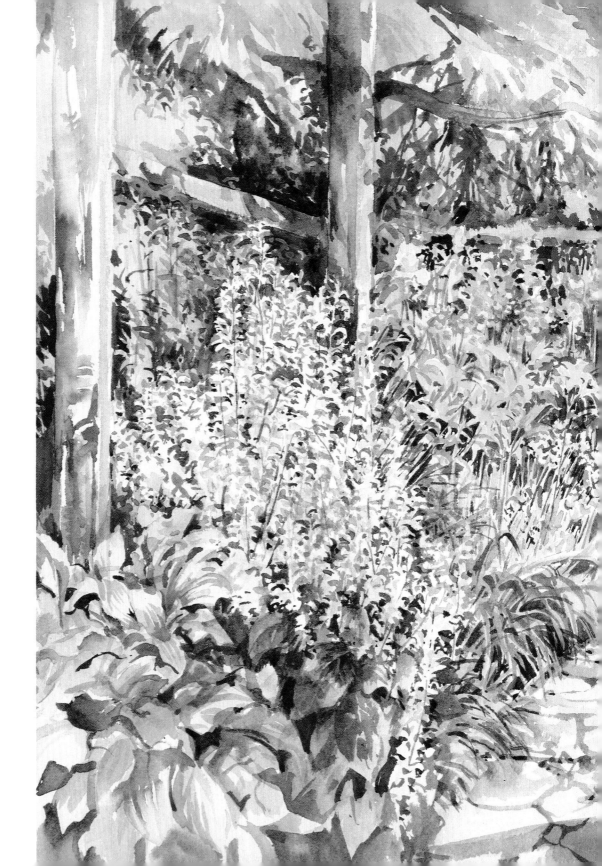

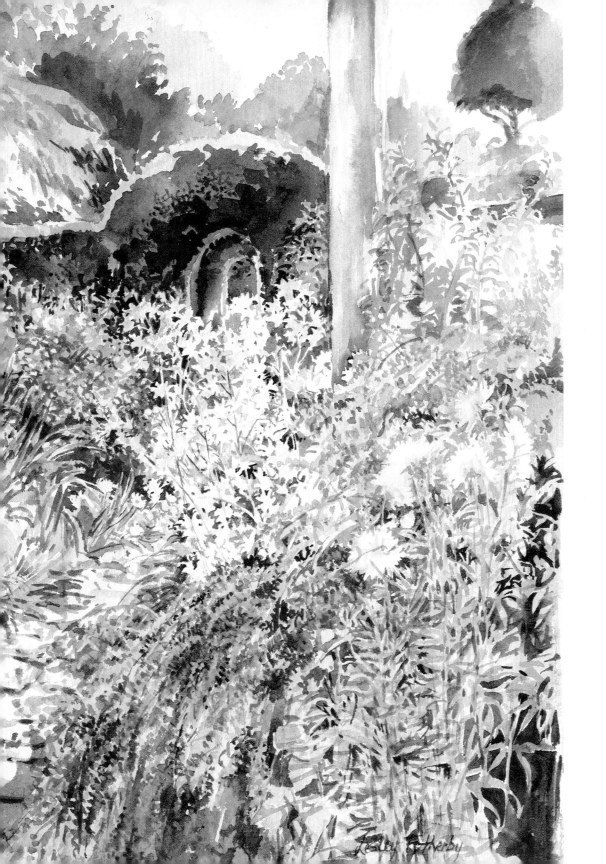

Lesley Fotherby

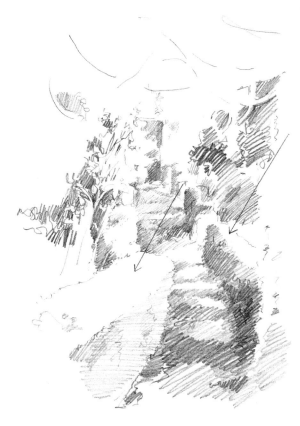

Here the light source is not so easy to locate because it is confused by overhanging branches and shrubbery. It is coming from above, of course, and filtering through to the tops of the hedges; the sides of the hedges on the right are slightly darker than those on the left and so we can deduce that the light is coming from the top right of the picture. The sides of the hedge on the other side of the path are in some shade because the light source is being interrupted and because it won't hit a vertical plane as directly as a horizontal one.

We looked at fences in some detail in the section on perspective, and found that they follow the rules we have discussed on perspective and directional light. Look particularly at the point where an upright stake of a fence meets a horizontal, and you will see that it casts a shadow across the top of the horizontal, breaking up the line of light that hits this surface. I like to use fences in a composition wherever possible, as I find the rigid pattern contrasts well with wild, unstructured foliage.

Steps are the most complicated garden structures. However daunting they seem, though, don't despair – even they have to follow basic rules. Light is the key to understanding how to portray steps. Think back to the box you drew, as most flights of steps consist of a series of elongated boxes set on top of and slightly back from each other. Light from above hits the top and leaves the vertical plane in semi-shade.

The drawing on page 94 is probably the easiest view of steps. I was seated in front of and slightly to the side of the steps and my viewpoint was about level with the middle steps. If you remember what happened to the board you propped upright and then let fall to the floor, you will

understand what is happening to the planes of the individual steps. We see the vertical part as we saw the upright board, its dimensions undistorted. The tread of the step is like the flat board, compressed, only more so because we are looking at the steps from a lower viewpoint. What we are left with is a series of shaded rectangles divided by thin strips of light. The steps on page 4 are more difficult because they curve round a flowerbed. For these, I was sitting much closer to them to do the drawing. The principle of light treads and darker uprights holds true, but because I was so near to them I had a very different view of each step; I saw the tread of the bottom step almost directly from above and, as the steps got progressively higher, not only did they appear smaller but I saw less of the tread each time until it disappeared entirely at the top of the flight. Try this

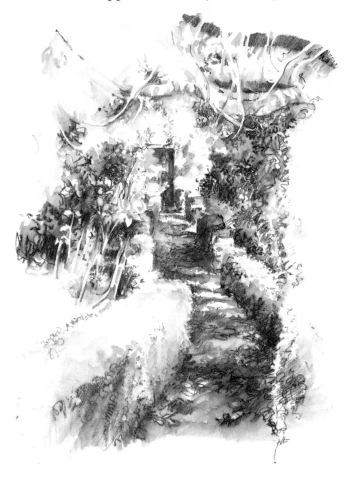

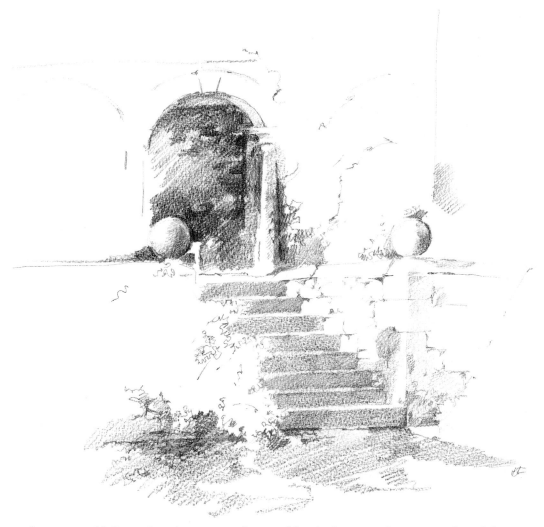

for yourself. Put a book on your lap and look down at its cover, then lift it up until it is just below your eye level and see how the shape of the front of the book has flattened out. If you lift it just a little more so that it is direct-ly in front of your eyes, you will see that this part of the book disappears altogether and all that is visible is its spine.

To get the curve of the steps, first I put in the outside line, so that the steps followed a fixed line, which I advise you do even if it is a straight flight. For instance, in the first drawing, I initially looked for the angle of the steps and the shape of the triangle they made with the wall before thinking about individual steps.

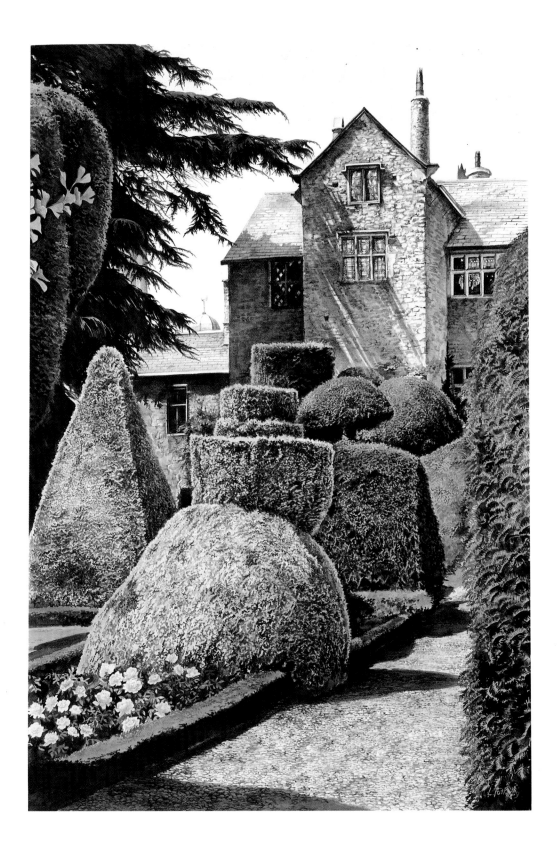

Other Drawing Materials

Pen and Ink

The drawing of steps at Hidcote on page 78 was done using a dip-in pen and indian ink over very diluted indian ink, which I had applied with a brush. Two types of indian ink are available; waterproof and non-waterproof, both are lightfast. Waterproof ink contains shellac, and if you put it on a palette with a brush it can be mixed with water and applied direct to the paper. It dries out quickly on the palette and once dry cannot be remixed with water as it forms flakes. It is a very dense ink and when diluted has a slightly brownish tinge to it unlike non-waterproof ink. This ink contains Chinese Stick inks, and gives, when diluted, a softer, cooler, blue-grey colour. Used straight from the bottle both inks look the same. NB Use distilled water if you dilute them.

Dip-in pens are very versatile because you can vary the type and thickness of the line you use by putting more or less pressure on the pen. Density of tone is achieved by drawing lines close together, the farther apart or more broken the lines, the lighter the result. Try some of these examples for yourself. As with pencil drawing, relax and try some broad sweeps with the pen. Repeat this, lifting the pen from the paper so you achieve a lighter, broken line. Then try a series of lines, close together and then farther apart. If you look at these with half-closed eyes, you will be less aware of the individual lines and see how the tone changes from light to dark. The rest of the examples, opposite, show different experiments with shapes and patterns, which if you look back to the drawing of Hidcote on page 78, you will see I have used to build up the textures of the plants. Try these and some of your own to discover what pen and ink can do.

The sketch of a magnolia tree on page 80 was done using indian ink and a brush; you can see that I have used it in a dilute form in some areas and directly from the bottle in others. It is a combination of materials well-suited to this subject, because magnolias have very dark, angular branches.

I have used short strokes, putting them together to form the shapes of the branches. Notice I have applied less pressure on the brush to create the thinner branches.

If you do not want to juggle with bottles of ink, you can use one of the many drawing pens, which are available. Make sure the ink is permanent. These have the advantage of giving a continuous, consistent line without you having to bother to dip them in ink and so are easy to use outside. The downside, though, is in the lack of variation you can achieve within the line. As with every medium you have to exploit its particular qualities and the continuous, unvarying line you get with these pens is something to make the most of. Below I have shown this line by drawing the pen straight across the paper and then, lifting it to get an uneven, broken effect. Take your pen and, starting at the left-hand side of the paper, draw a

meandering line across to the other side. Do not lift your pen from the paper; instead think of it as an unravelling ball of string. You will now start to see what effects you can create. Below I have experimented with this type of line relating it more now to the patterns of grass, foliage and flowers found in a garden.

Watercolour Pastels

Watercolour pastels come in a wide range of colours but on page 93, *Hedges Leading to a Doorway*, you will see a sketch using just the black watercolour pastel. They can be applied like any other pastel, but once on the paper water can be added to draw out the pigment and produce a wash of paint. If you look at the hedge in the foreground of the picture you will see that I have drawn in only part of the texture of its leaves and then with my brush added water and pulled out enough pigment to give form to the hedge by creating shadows. This drawing took shape the opposite way round to the one of Hidcote on page 78, where I started with dilute ink and drew on top, but here the line drawing comes first. The examples below show what the pastels look like when first applied and then when water has been added. The water intensifies the tone of the pastel as well as forming a wash. NB Do not try to get rid of the pastel lines when you add the water – it is not watercolour paint and the drawn marks are part of its special quality.

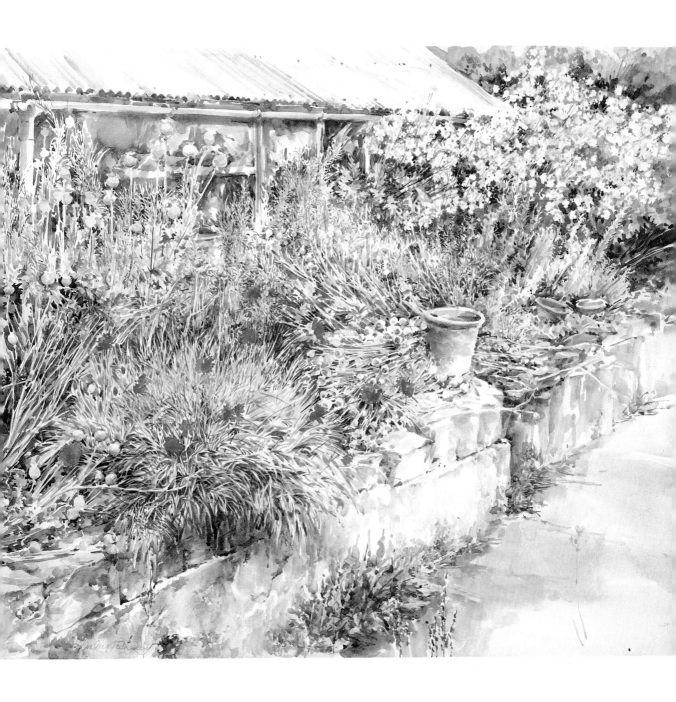

Symmetry and Ellipses in More Detail

Drawing and Painting Pots and Watering Cans

If you have a small garden or a balcony you probably make the most of the space available by planting up containers, and even if you are painting a large garden pots are often used as a focal point. Because they are so important I am going to look at how to draw symmetrical objects and how we can apply what we already know about ellipses to things like plant pots and watering cans.

A symmetrical object is one that can be divided into parts of equal size and shape on either side of a dividing line, the dividing line being the line of symmetry.

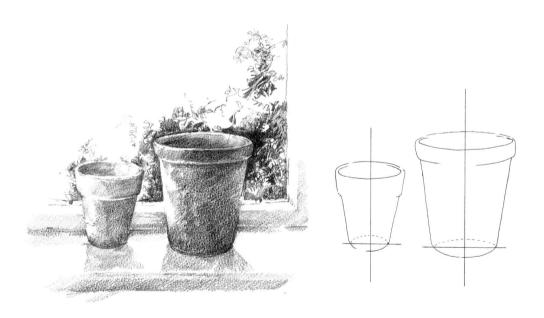

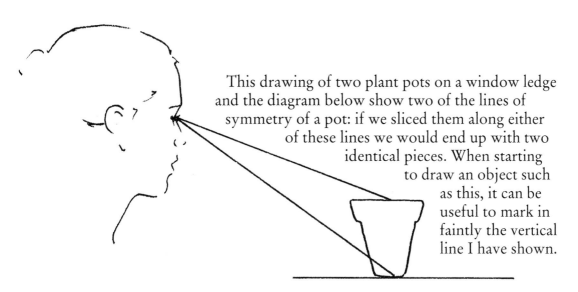

This drawing of two plant pots on a window ledge and the diagram below show two of the lines of symmetry of a pot: if we sliced them along either of these lines we would end up with two identical pieces. When starting to draw an object such as this, it can be useful to mark in faintly the vertical line I have shown.

If you do this you can compare what you draw on either side of it. The tops of the pots are ellipses (see page 59), and as are the bases, but they are not ellipses of the same shape: the ellipse at the bottom of a pot or any round object will be less of a flattened circle than the top (its height will be greater compared to its width than in the top ellipse) because we are viewing the top and the bottom from two different angles.

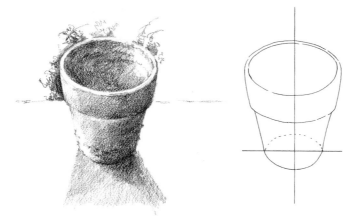

We cannot see the whole of the bottom ellipse but this is the reason why we always see the curve on the base of a pot as greater than its equivalent at the top. As we alter our view of the whole pot, the ellipses will change accordingly. For instance, in this second drawing the pot is further below my line of vision, and I can see more of the inside because the ellipses are

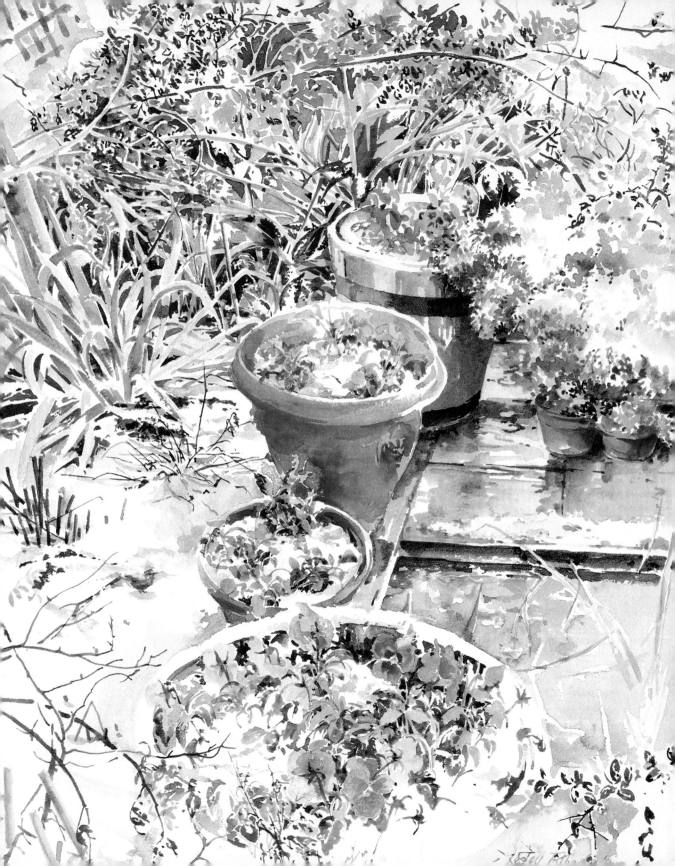

rounder. As with the steps on page 94, and paving slabs on page 86, different effects will be created as we look at them from different positions.

Once we have the shape of the pot we need to make it look like a solid object. All three of the pots on the previous two pages were lit from behind and from the left, and consequently the left-hand side of the outside of the pot is lighter than the right. However, inside the pot the opposite is true: the left is in shade while the light bounces off the inside of the right of the pot.

Objects with ellipses can be difficult to get just right. If you are having problems, make sure that whatever you are painting has something in it which interrupts the ellipse, a plant straggling across perhaps. This way the scan that the eye makes of the ellipse will be stopped part-way round and will have to start again, thus making any imperfections much less apparent.

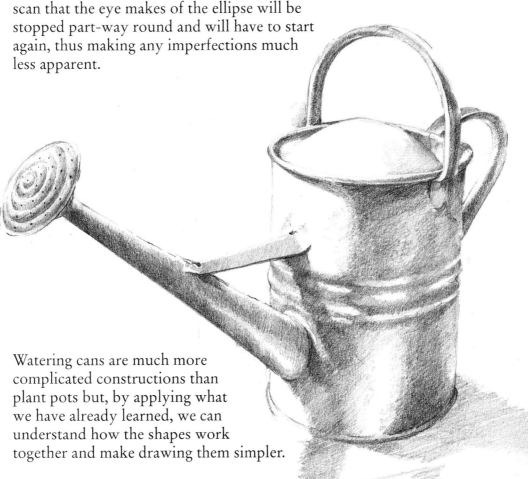

Watering cans are much more complicated constructions than plant pots but, by applying what we have already learned, we can understand how the shapes work together and make drawing them simpler.

Here are the lines of symmetry which help to give us the cylindrical shape of the can. To ascertain the angle of the spout, hold your pencil out at arm's length and lay it along the line of the centre of the spout (see pages 68–69). You can further check your positioning by looking at the little triangle just above the spout. Once you have found this line you can position the rose in the same way.

You do not necessarily have to put in all these lines before you start to draw, though do so lightly if you wish. The most important thing is to understand where they are and to have in your mind the 'skeleton' of the structure. As you draw, compare where one thing is to another all the time, and look for other lines that will help you with these comparisons. For instance, where is the top of the rose in relation to the top of the can, and again to the top of the handle? Use your pencil held out in front of you to help. Look for the source of the light and see how this defines the structure, and when you are shading in the darker areas work your pencil marks round to follow the shape of what you are drawing, which will help to capture the character of the subject.

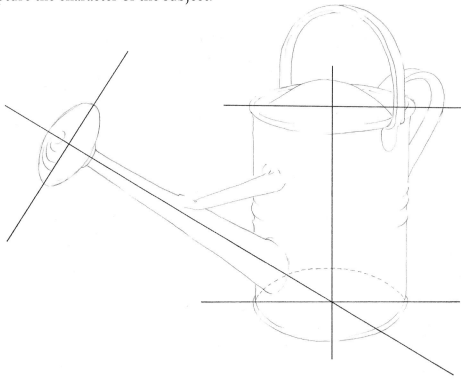

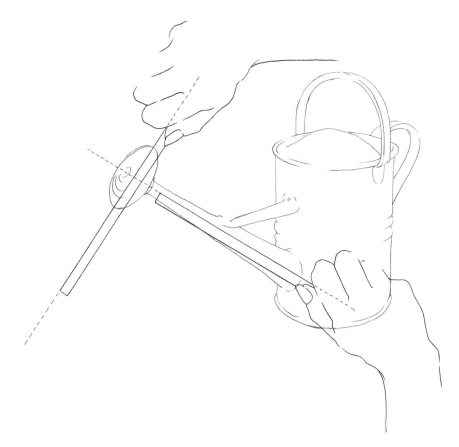

The painting of winter-flowering pansies on page 102 was done from a window on a winter's day. I was looking down at the pot and tubs and, as the one in the foreground was directly below the window, you will see how round the rim ellipse is compared to the tub furthest away. In fact the ellipses get progressively more compressed as the pots get further from the window. Watch out, though, because it is not a nice simple progression! All the pots are of different heights, and so this affects how I saw their rims, as does their distance from me, so when you are doing a subject like this, don't just presume what will happen. Always check the widths and heights with your pencil or brush.

Because there was a light sprinkling of snow the rims appeared white so I left the paper unpainted, and as you can see I have broken or interrupted each ellipse so that my accuracy does not bear too much scrutiny.

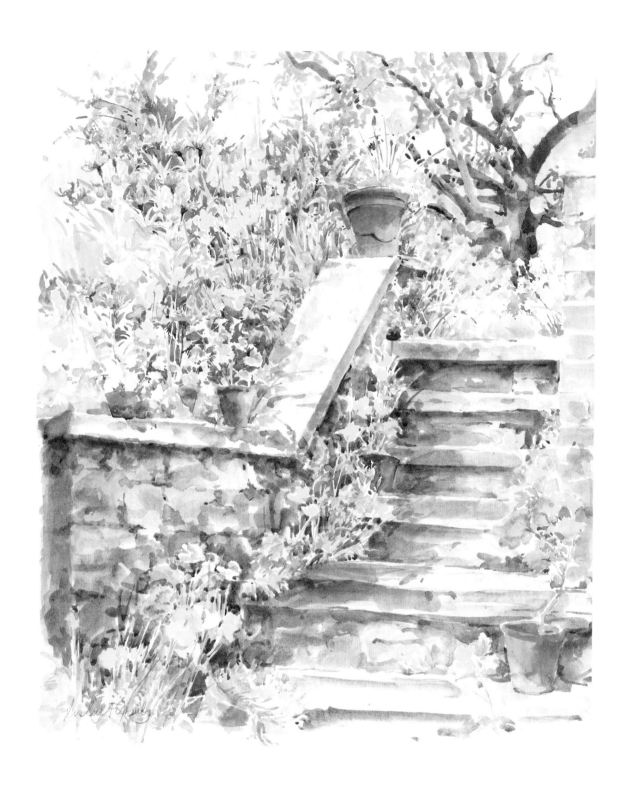

Painting a Corner of Your Garden

When we look at our gardens we are aware of their overall effect and of how we have planted them to create vistas of colour or to see how different plants look when they are grouped together. These grand views make wonderful subjects for paintings, but equally interesting are the odd corners of the garden which we may not have considered painting at all. The painting *Welsh Poppies and Flower Pots*, opposite, was done as I was sheltering from the rain. I had gone to a garden to paint a lovely view of the flower borders and when it started to rain I sought shelter at the back of the house and found this unexpected subject. It is interesting partly because it is on several levels, which allows you to explore the foreground and then be led through to the garden beyond, and partly because of the colour which is fairly limited, all the flowers are yellow, orange or blue. The broken pot at the top of the steps is what first caught my attention and this gives a focus to the picture. From it we are led in one direction down the steps via the poppies to the foreground and in the other direction we are given a glimpse of what lies in the garden beyond. Sometimes it is not the most obvious viewpoint which is the

most successful and so it is worth walking round the garden and looking at things from different angles.

Sometimes an idea for an interesting painting may come as you are working outside, collecting leaves in a wheelbarrow, digging or potting cuttings in the greenhouse. In each of these activities, you will have together a group of things, like a wheelbarrow and a rake, or a pile of pots, a fork and a trowel, which because of where they are and how they have come together, will make interesting subjects.

Make yourself a viewfinder and take it round the garden with you. Have a look for subjects to paint, in the shed and the greenhouse or on the kitchen windowsill. Hold the viewfinder close to your eye so you see a wide view area, then take it further away from your face so that you are narrowing your view and focusing in on part of the scene. If you have a sketchbook, make some quick drawings and try out different compositions. Draw rectangles the same proportion as your viewfinder and sketch inside these, or make your viewfinder the same proportions as your sketchbook and draw so that what you see reaches the very edge of your page. The shapes created as your drawing or painting comes in contact with the side of your page are as important as any in the picture.

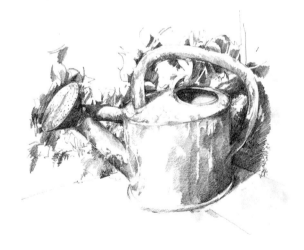

Conservatories and Indoor Gardens

From the Palm House at Kew to a cold frame in a back garden, refuges interest a painter because they provide an exciting combination of hard, manmade shapes, and fluid plant forms. Also the reflection of light adds a different perspective.

In a friend's garden, I was struck by a stark frame with sharp angles and the haphazard shape of plants. Firstly, I painted faint lines of the sheets of glass, their supports and the angles of the walls and greenhouse, so I had a framework on which to hang the rest of the picture (overleaf). A broken line, will give you sufficient information and allow you to make the wall uneven or to have plants growing up which would interrupt any of the lines.

Because watercolour is a transparent medium it is well-suited to capturing the effects of light, but in order to capture the glimmering effect of sun on glass you must use the paint lightly and in a dilute wash. I used Cerulean and Cobalt Blue for the glass and I left some of it unpainted. As a complete contrast, the dark wall behind helps to enhance the lightness of the glass. I knew the reflection of the post would change as my painting progressed so I fixed this and the other reflections early on. In some places we see the outline of the glass as dark against light and in others light against dark. This needs to be put in at an early stage or you can get very confused as these effects constantly change. All these lines give structure to a picture but should not dominate it, and so the plants which cut across and break them up are very important – the pink foxglove on the right and the four white ones behind the cold frame.

Take a piece of paper and cover up the red hot pokers behind the wall, and you will see how important these are to the composition. They take your eye right back and give the picture depth, stopping it being cut off at the wall, and they give you a shock. The rest of the painting is dominated by a tasteful mixture of the complementaries, yellow and mauve, but these

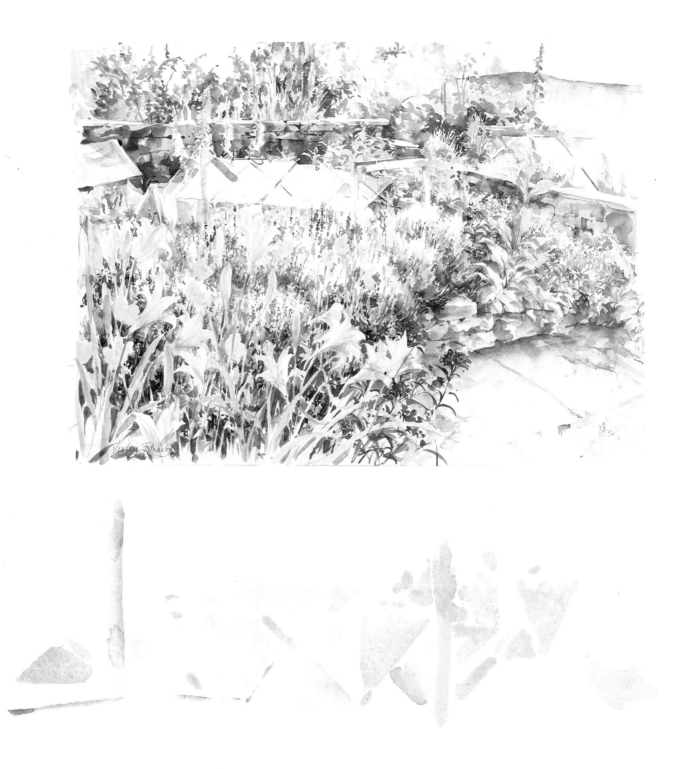

would be rather dull without the bright orange flowers leering over the back wall.

Inside a glass house the light is flooding in from all directions and usually we see plants back-lit, their silhouettes accentuated. We become very aware of the patterns the plants make as their leaves intersect with structures around them. In the painting of the Palm House at Kew, below, I used the techniques I showed you for the painting of the indoor plants on pages 25–29. After putting down a light colour wash to show where the pillars and the stairs were, I painted in the lines of the centres of the fronds that gave me the 'bones' of the plant and the rest of the fronds were painted with single brush strokes out from this centre line. Technically the most difficult aspect of painting a subject like this is getting the plant to appear and disappear behind pillars and stairs. You can use masking fluid (see page 66)

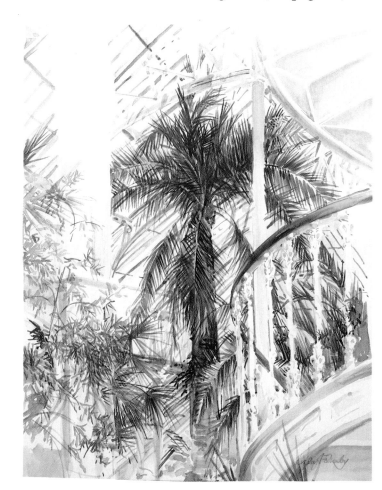

to block out these structures and paint what is behind over the top of it but this gets rather complicated when, as in this picture, some plants are behind and some in front. What I did was to paint a blue wash in between the uprights of the stairs and the pillars, just enough to pick them out and then I painted the palm and the lines of the windows. Blue is a component of green and grey, so I had no trouble with the overpainting.

Try putting several pot plants on a windowsill and drawing them with the light behind them. Forget about the individual leaves; see what patterns they make as they intertwine with each other.

Balconies and any areas where the garden and the house overlap offer similar subjects. The living area and the garden are coming together in the picture, below, and we see the effect of the warm light intruding into the cool building; the patterns of the shadows cast by the plants outside break up the flat, paved area and the plants in pots contrast with the hard uprights of the pillars. I think this is one of the most fruitful sources of subject matter and you do not need to have a conservatory. Try painting a pot plant on the window ledge with the garden behind it, or opening the back door and painting part of the garden through it.

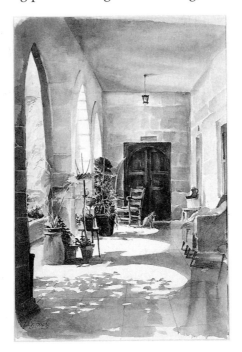

Trees

Very few gardens are without at least one tree and some consist mostly of trees of different shapes and colours. They may be the main subject of your painting, or act as a background or foil for the other plants. Have a look at the painting on page 83; the copper beech in the West Garden at Hatfield House contrasts with the bright colours of the herbaceous beds and makes them seem more intense. It is important to get to grips with the structure of the trees. When a tree is in leaf most of the branches disappear and we are faced with what can seem an amorphous mass of green with a trunk at the bottom. Added to this, the mass is made of hundreds of individual leaves which further distract you from seeing the tree's basic form, but don't despair.

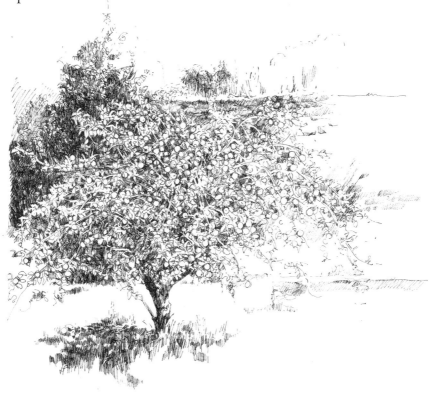

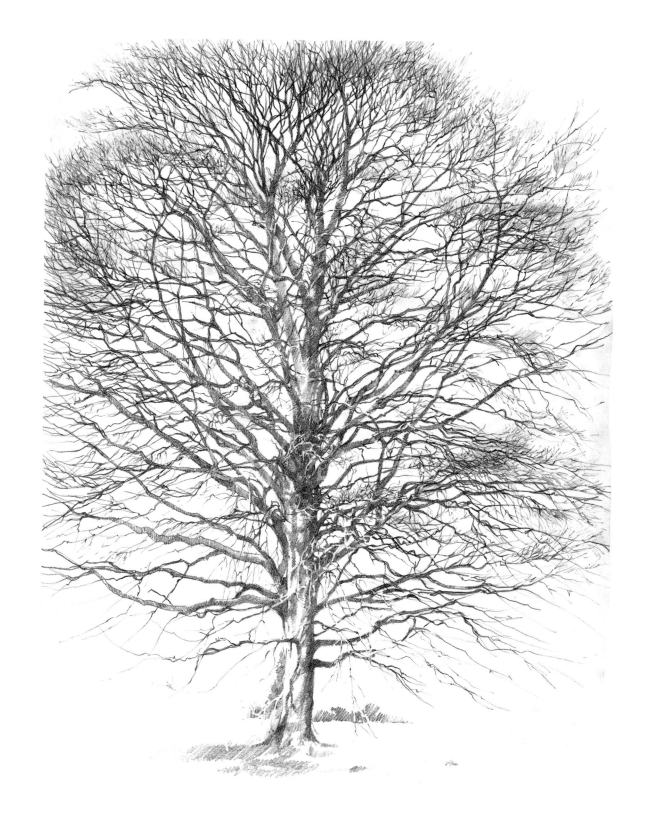

All trees are different, of course, but the characteristics of the beech at Kew Gardens opposite are similar to many other deciduous trees. Firstly, look at the length of the trunk below the bottom branches and how this length compares with the height of the rest of the tree. Most people draw tree trunks much too large, but the proportion of branches to trunk is about 5:1. Even the little apple tree on page 113 has its branches three times the length of the trunk and the width is about six times. The branches of the tree start low down and, just above halfway up, the trunk becomes narrower, and divides again and again, until the twigs become almost impossible to see individually. This seems rather an obvious thing to say, but the gradual nature of the change from trunk to twig is very important. The lines flow into each other and the branches coming from the main trunk do so at an upward angle and are wide at the point where they leave the trunk then taper so it is very gradual. Put your hand out in front of you so that you are looking at your forearm and palm. See how your wrist becomes your hand and your hand your fingers. It is a gradual growth one into the other and you can feel your thumb in the palm of your hand before you see it as a separate digit. Think about the trunk and branches of a tree growing in this way.

Looking up at a tree with the sky behind it, it is easy to think of it as a two-dimensional silhouette, but of course it is three-dimensional. It is important to remember, especially when the tree is in leaf, that some of its branches grow towards us and are picked out as light shapes against the trunk.

Branches will hold a canopy of leaves, which we see as a solid mass. The diagram above shows where on the tree these canopies of leaves will be borne and if you look across to the beech drawing you will see how they relate to the concentration of twigs borne up from the main branches. I think a tree looks rather as if it is made up of a series of umbrella-like shapes. If you half-close your eyes you are less aware of the individual leaves and are able to see the broader forms.

Find a tube of some sort, a cardboard one will do, and also make your-self a cone. Now get an umbrella. Put the tube and the cone somewhere where there is a strong source of light from one direction. For your drawing the objects need to look solid and so the way you put in the shadow is important. As you make the marks with your pencil, think how the object would feel if you passed your hand around it, and curve the lines you are making accordingly. The eye will follow these lines and the illusion of the solid shape created on the flat piece of paper will be greater. If you want to understand further what this curve will be, take a piece of string or wool and attach it to the top of your shape. Wind it round until you get to the bottom leaving a small gap between each strand. Draw just the string, and you will see that it tells you as much about the shape as the previous drawing. Prop up the umbrella somewhere where the light source is from above and make a drawing of it. You are imitating the effect of light on a canopy of leaves. Nothing we see in nature conforms neatly to these nice symmetrical shapes: unlike the tube, trunks are gnarled and grow at odd angles, conifers seldom are as tidy as the cones we have drawn. Look beyond the surface pattern and texture to make sense of what you are seeing.

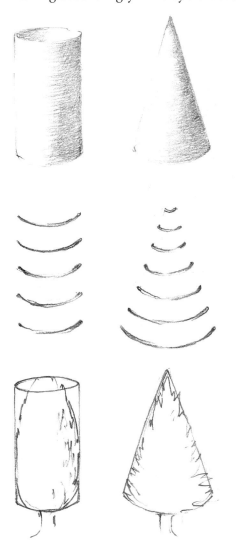

Blossom trees are irresistible to paint, particularly as their beauty is so short-lived. Of course the main problem is leaving areas of white or lightly tinted paper in the right places and painting the rest of the

tree and the background to emphasize the blossom. You can paint the blossom with masking fluid, and then go ahead and paint the rest of the picture without fear of going over anywhere where the blooms are. I personally think masking fluid gives a rather blobby effect and the edges of the lines never look the same as the edges of the watercolour shapes, so I prefer to make a few mistakes and leave spaces for the blossom. The technique is the same as we used for the white flowers (pages 64–66), i.e. finding for the negative shapes to show up the positive ones. A problem which can occur when painting light flowers against dark is that they can look as if they are cut out so it is important to vary the tone around them. The painting on page 67 of the magnolia tree was done by painting the leaves and leaving white paper where bloom appeared. Students often worry when painting something like this that they shouldn't mix the same green twice, but I think this is a good thing, as there are many greens within one tree.

Another method is to use an opaque white paint, like gouache over watercolour, and if you want to use that, fine. l am a great believer in 'if it works use it'. However, an opaque medium will not only give you a white area, but will also change the surface texture of the painting. Also you should apply the paint after the rest of the watercolour is finished, otherwise the white will mix in with the other colours and their transparency will be lost. It is possible to put a glaze of colour over gouache but it needs a lot of practice and a very delicate touch. More of that later on page 131.

Finally, a word about painting tree trunks, which are rather neglected and usually painted brown as an afterthought. In fact, they can be grey, green, ochre, nearly black and many other colours besides. As with everything else, it pays to look at your subject carefully.

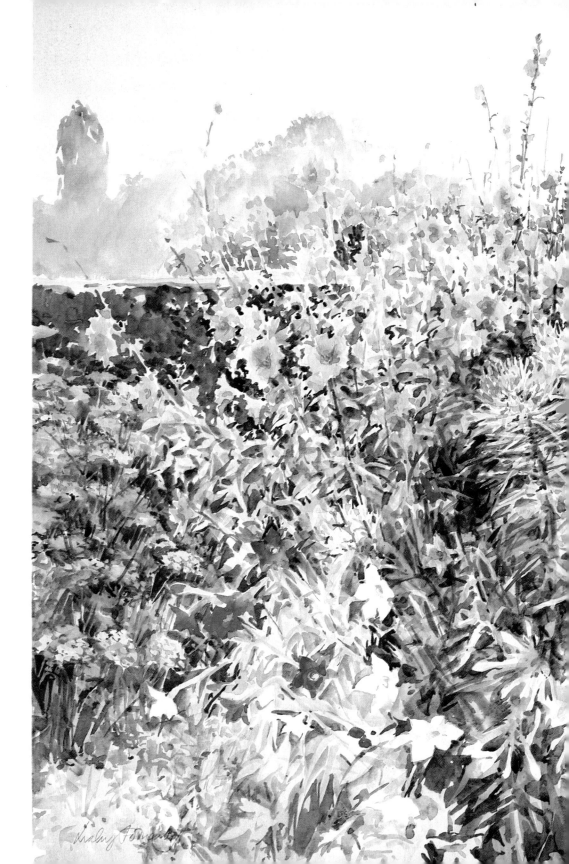

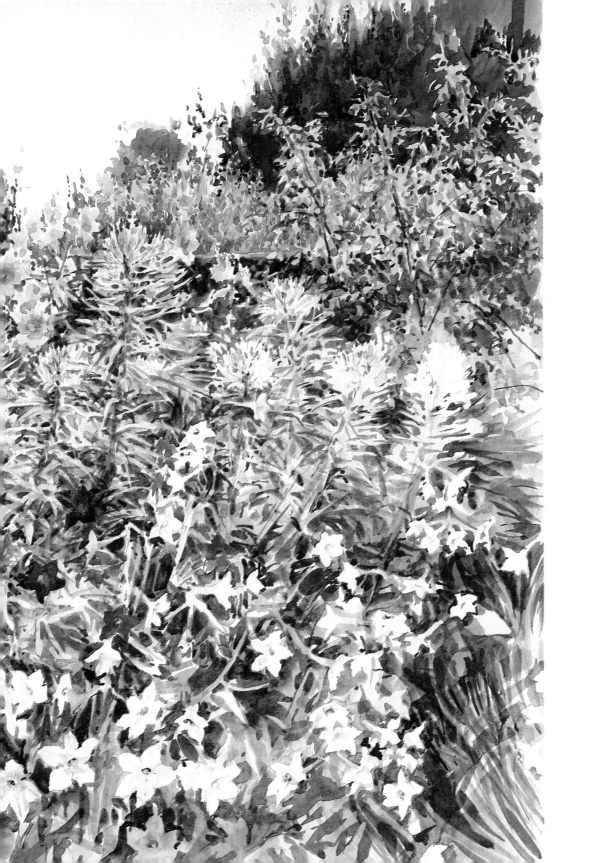

Herbaceous Borders

On pages 25–29, we looked at how plants that grow together can have very differently shaped leaves of varying greens. Herbaceous borders, in the same way, bring together a variety of plant forms in a way that, because they are juxtaposed, we see them anew, and unlike our pot plants they can be any colour you can think of!

Firstly, I would like to show you some techniques for recording information on how plants grow and what their characteristics are. It is useful to have a sketchbook with you as often as possible so that you can jot down things which interest you. It doesn't matter how slight the sketches are or if you don't use them at the end of the day. By simply committing them to paper you are building up a store of knowledge. I often do preliminary sketches, e.g. for flowers, which usually take about five minutes. It is good to have a time limit, because it forces you to look for the essentials.

The lilies in a border in the scented garden, opposite, were just coming into bloom and the flower heads were pulling the stems over the path, looking far more beautiful than if they had been staked. The curved lines of the stems were the first marks I put down, and from these I built out the leaves in a series of short pencil marks and outlined the buds and the flowers. Then I shaded in the shadow they made on the path and the dark wall behind them. I left some of the leaves and the buds white to show how the light was picking them out, and at the same time I darkened some of the leaves further down the plant to contrast with them. Against the wall, a rose whose branches were growing up at an angle to the lily stems, contrasted well with the lilies. I wanted to record the relaxed, tumbling effect of the border and to an extent how blisteringly hot it was. There was an air of time being suspended and this part of the garden seemed to encapsulate that feeling.

The poppies in the next sketch on page 124 grew very differently. These are double flowers with large solid heads borne on upright stems and were growing in a herbaceous bed with delphiniums, another upright plant.

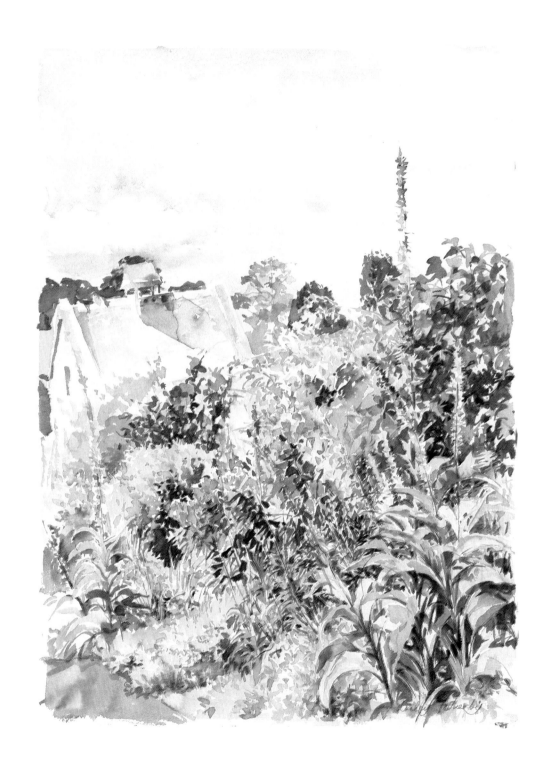

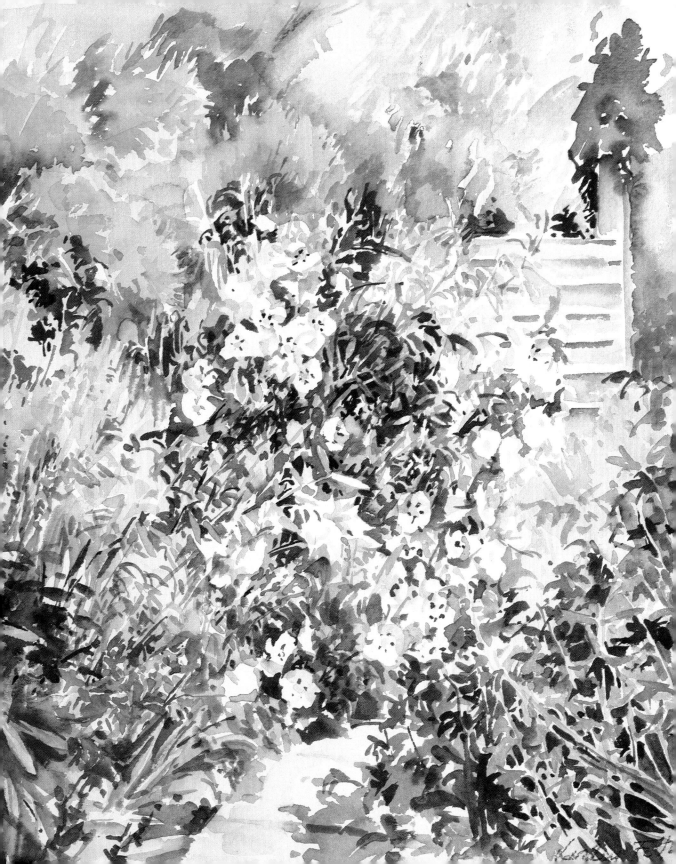

What interested me was the jumble of leaves as they overlapped in the bed. In a situation like this I don't worry too much about absolute accuracy but about achieving an almost abstract pattern. I was also recording the relative size of the blooms as I compared the ones near to me with the ones in the distance, and where they were in relation to my eye level. The small amount of shading is there to indicate the dark hedge behind and if I was using this sketch to help me with a painting, it would show me the relative tones of the flowers and the background.

Take a sketchbook into the garden or look out of the window at a group of plants. With a soft pencil start drawing the outline of a leaf and, rather than stopping when it meets another leaf, carry on without lifting your pencil from the paper. If you find this difficult at first use a photograph of any types of plants to practise with and then go on to the actual thing.

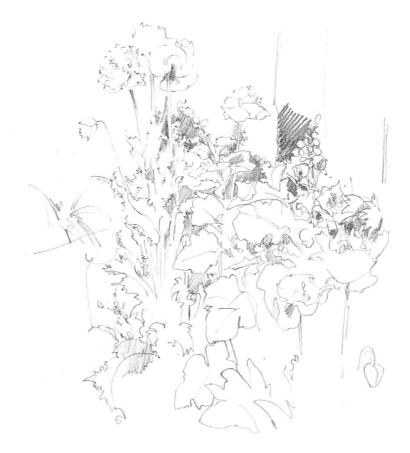

Collecting information will not only tell you what individual plants look and grow like, but it will also help you to choose your subjects. As you become used to looking at things and putting what you see on to paper, you will become more aware of what makes a successful composition. The three paintings of herbaceous borders are from different angles: *The Herbaceous Border at Snowshill* and *Cistus in the Scented Garden* on pages 122 and 123 were both done on the spot, while *Cleome and Nicotiana – Newby Hall* on pages 118–119 was painted from watercolour sketches and drawings. The lattermost is the one which brings you closest to the border; the only structure of the garden we see is the hedge, the line of which is broken by the mallow. I had to rely on the actual plants and how they were growing to compose the picture. When I started to paint I put in the lines of the cleome and mallow stems fanning out, leaving space for the nicotiana, and then I painted the lines of the stems in a very pale green (Cobalt Blue and Lemon Yellow) so that I was not committed to a deep colour too early, all to conscious that the biggest pitfall in this composition would be to make these lines too dominant. The nicotiana are very important in breaking up

the space at the bottom of the picture, the stems draw our eye downwards and the nicotiana explode out in every direction. The copper beech in the top right-hand corner and the yellow achillea are also vital. Although they look peripheral, they give a sense of imbalance to what might otherwise be too symmetrical and boring a composition. Of course I was greatly indebted to the person who planned the border and who also thought of these things but it is still very important to consider how you use what is before you and adapt it to your needs. The nicotiana didn't grow exactly in that pattern, for example. Having got the idea of the star-like shapes I placed them where I thought they would have most effect;

I was trying to portray the *effect* of the border rather than make an exact representation.

When we looked at the qualities of particular pigments earlier in the book we saw how they differed in their translucency. Look back to the diagram on page 58 and you will see how much more covering power Lemon Yellow has than Raw Sienna. I built up the colours, particularly the greens, by layering blues and yellows as well as mixing them together. You will find that you can modify a colour by putting a layer of one of the more transparent ones over what you have already painted, a technique called 'glazing'.

Cistus in the Scented Garden on page 123 is a view further along the border from the drawing on page 121, and you can see some of the same Regal Lilies in it. It is a smaller painting than the one I have just described, about a quarter the size and was done on the spot in an afternoon. I chose a viewpoint looking along the border this time and so I had to achieve a greater feeling of distance, the path in the foreground and the steps behind the cistus helping because of their relative size; I also used tone, colour and detail to give the illusion of space. In the foreground I have used stronger colours and deeper tones than in the area behind the cistus and I have put more foliage and plant detail into the front of the picture. Try covering up the small, orangey rectangle above the steps, and you will see how important it is to the whole composition. It gives a point of reference in the distance so that we feel the undergrowth carries on beyond it and it accentuates the vertical break in the composition at this point; our eye follows the left hand side of the path in the foreground, explores the plants in the middle distance and then carries on up the steps. I exaggerated the colour because I was so taken by it and because of what I knew it would do for the picture.

The herbaceous border at Snowshill Manor on page 122 slopes downwards along the side of a wall. With the foxgloves above me, I sat on the ground to paint the border, which gave a very different feeling of scale to the previous picture. See the seed-head and the building in the distance break up the strong diagonal which would otherwise have dominated the picture. When choosing your composition, it is a good idea to think about your height and its distance from the ground. Sometimes I like to take a painting home and look at it before it is completed, and then I make sure that I have some back-up sketches.

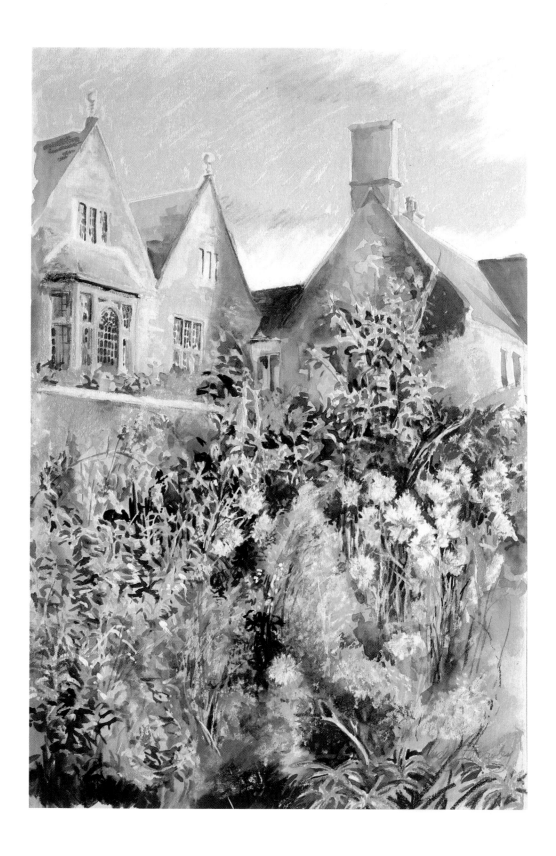

Other Mediums

So far I have talked only about pure watercolour used as a painting medium on its own, but it can be incorporated with other mediums, like gouache and pastel.

Pastels are sticks of pigment bound together with a medium, usually a mixture of gum and chalk, and there are many different sorts to choose from. They vary in their degree of hardness, and the type of line they produce will relate to how soft or hard the pastel is. I have used soft Rowney pastels and harder Conté ones. I like to use more than one type in a picture because this gives me a wider choice of line. Most makes of pastel can be bought in ready-selected boxes of colours or you can choose your own; it is a delightful experience to look through cabinets of wonderful colours and choose which you want to make up your box. Beware, though, because this method can be expensive – I always end up with twice as many as I intended buying!

As well as the type of pastel you choose, the paper you use will also affect the end result. As with all mediums the surface you use them on is vitally important. Try shading in an area of smooth paper, like cartridge or bond paper, with pastel (whatever sort you have). Press down hard at first so you get a dense area of colour and then gradually lessen the pressure so that you start to see some of the paper appearing through the marks. Try this again on a paper with a grainy surface, like pastel paper, to see the difference. If you have more than one type of pastel try this exercise again with a different sort and you will see their individual qualities and what effects you get combining them with various papers.

The picture on page 127 uses Rowney soft pastels, Conté pastels and watercolour paint on cream Mi-Tentes pastel paper. I chose cream because of the warm stone of Hidcote Manor and the yellowy greens of the autumn border in the foreground, and I have allowed some of the paper to show through in both these areas. When you are using several mediums together there is always an element of experimentation and I don't have any set rules which I follow when I start this type of work. It would be

possible to put in some flat areas of watercolour for the planes of the building, the roof say, and then colour in some pink shapes to represent the dahlia heads. This would really tell you most of what you needed to know about where the building was, how much of it you would see, the difference in scale between it and the foreground, where the wall would need to go and a lot more besides. Equally, the orange bit of the wall could be a good starting-point, as again it would fix the position of the building and the border. You could then draw in pastel the lines of some of the plant stems in the foreground and some of the building's shapes behind. A little in key places early on can be more help than a detailed drawing which begs to be coloured in. Once I had put in these markers, I used soft pastel quite densely for the sky, although you can still see the direction of the pastel marks and glimpse the coloured paper between them. This is deliberate, as I wanted to get the effect of movement in the sky, and I didn't want to disguise the fact that I was using pastel, rather make its special characteristics show.

Hidcote Manor is in watercolour and pastel, although predominantly watercolour. I knew that whichever colour I put on would be modified by the tinted paper, and so give a feeling of unity to the building, and that the softer medium of watercolour would convey a feeling of distance compared to the more definite foreground where I have used a lot of both types of pastel. Here I have put on layers of pastel and paint; where I needed density as with the dahlias it is soft pastel and where I wanted a grainier, more linear effect the harder sort. I have used paint to modify colours in places and to pick out plant shapes in others. Using water on a pastel picture also makes the colour run from the pastels (not in the same uniform way as the watercolour pastels) and this gives an extra interesting unpredictability to the process.

If the pastels run too much or in the wrong place just wait until the paper is dry and put on another layer. Unlike pure watercolour this can be light on to dark and like me you might find it a relief sometimes to be able to cover your mistakes with such ease.

White gouache is often used in watercolour painting as 'body colour'. This is when it is applied at the end of a painting to highlight certain parts of the picture or to reinforce white areas. You will remember that I said great care should be taken to use white at the end of the painting process so

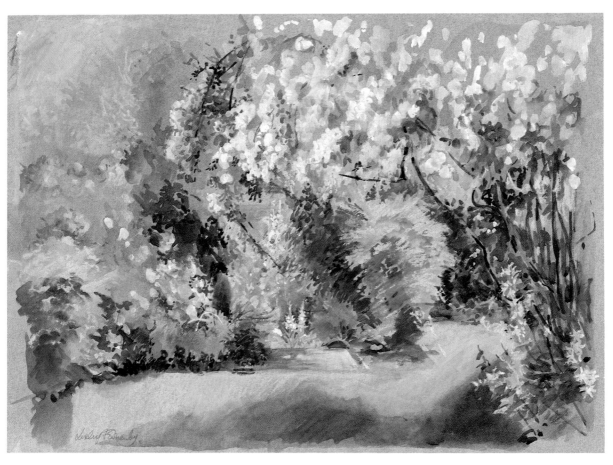

as not to introduce it into the other colours and make them opaque, this is very important as you want to keep the translucency of the medium. Here though I am going to show you a method of using gouache and watercolour together on tinted paper where I am laying the watercolour over the gouache, just to be awkward and prove that rules are there to be broken. Opposite are two stages of a painting of a cream rose which was trained over a tree stump and dominated the view I had of this garden. I decided to use a combination of pastel, watercolour and gouache and to build up the very light areas in gouache first, the roses and the distant foxgloves, then put in some colour with the pastel and

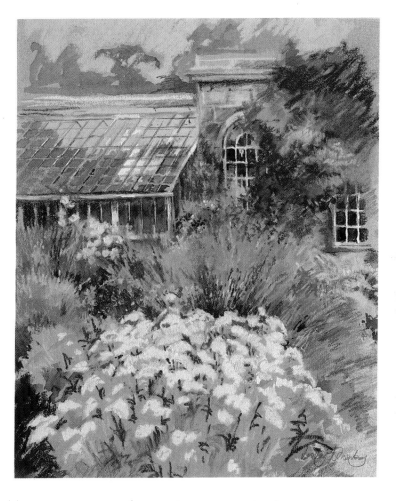

when the white paint had dried lay some watercolour paint over to tint it (the white paint is taking the place of watercolour paper and reflecting light back through the watercolour). As you can imagine this needs to be done with great care, the watercolour has to be put on gently so as not to disturb the surface of the gouache, and if you want to try using this method experiment on some odd bits of paper before you start on a picture. You will soon get the hang of how much pressure to use and how much water to have on your brush (not too much, or the gouache will dissolve again or, too little, the brush will rub the gouache off if it is too dry!). You will see from the first picture where the white paint was initially laid down.

Millgate House

Millgate House has a beautiful walled garden in Richmond, North Yorkshire. During the summer I spent many days painting and drawing there, and over the next few pages you will see some of the results. I am going to devote this chapter to one garden in order to illustrate, and I hope help solve, some of the problems everyone finds on entering a garden (even if it is their own) – what actually to paint, and how practically to set about it.

Going in to a garden is like entering another world, one which has been carefully and thoughtfully created and I think that walled gardens in particular give this feeling because once within them you are not usually aware of the surrounding landscape or of other buildings. Millgate House garden is crowded with plants whose contrasting textures and shapes are visually wonderful as you look around. I spent some time just walking. The first problem was where to choose to sit and paint with so much subject matter around. Painting outside means you are surrounded by your subject – it is not conveniently isolated on a table in front of you like a still-life – so as you turn your head you must get an idea of where the picture will start and where it will stop. However lovely it may be to gaze into a rose bush, that view will not necessarily make a good painting. As you walk round a garden, use your viewfinder, or if you haven't got one to hand make a rectangle with your fingers, to separate parts of what you are seeing from their surroundings. Sometimes the beauty of a plant is highlighted by being seen against the contrasting texture of a wall, a tree trunk or pattern of a gate (as on page 138). Do not presume that the only views available to you are from the height you are standing at. Look at something from a standing position, then sit down on a stool, then on the ground, which, although rather uncomfortable, can offer some interesting compositions. Some of the Impressionist painters painted standing in a trench, but I don't recommend you dig one of these in someone's garden! I painted the picture on page 135 sitting on the lawn with my board propped up slightly in front of me so I could get low enough to be able to look straight at the dominant peachy-coloured rose in the centre of the picture and to be able

to use the geometric shapes made by the window and the railing in the background as a contrast to the undergrowth tumbling forward in the border. If I had stood up, I would have had to position myself much further back to get the roses and the window into my picture and I would have lost the intimacy of being so close to the flowers. Look at this painting with the flower-pot covered up and you will see that this pot gives much more of a feeling of depth to the composition.

Before I painted this study, however, I was attracted by probably the most spectacular view in the garden, which you can see on page 134. The garden is divided about two-thirds of the way down its length by a series of stone steps surrounded by roses. As you look back up these steps you see the house which at this time of the year was also covered in roses. I chose to sit about halfway up these steps so that my eye was level with the top step, and I saw nothing of the lawn stretching between it and the house. I conveyed this distance by the change in scale between the flowers near me, the Welsh Poppies, and the roses and windows in the distance so the viewer really has to work to find out what is going on. The glimpse of the garden bench also helps to show that something exists between the trough with the conifer and the house – I also like the visual puzzle the pattern of the spaces between the wooden slats makes. This garden has been planted with great care and the juxtaposition of the two conifers, one at the top of the steps and the other on the balcony, is no accident. They were described to me by one of the garden's owners as punctuation marks. I have used them as the pivotal point of the composition, so when I started to paint I put them in as two green shapes which I used as guides for the position and size of everything else.

Painting large areas of foliage, like the bush in the top left of this picture can be daunting. This foliage is a mixture of rose bush and honeysuckle and it hangs over the steps. During the early summer, there were very few blooms, so I had to use the texture of the leaves to give an impression of foliage and change their colour and tone to convey the bulk of the bush. It is important not to get too involved with the patterns of the leaves before you have given an impression of the three-dimensional quality of the bush (half-close your eyes and it will be easier to see this). First put down washes of pale colours, a yellowy green for the rose and a bluey green for the honeysuckle over the area the bush covers. As this starts to

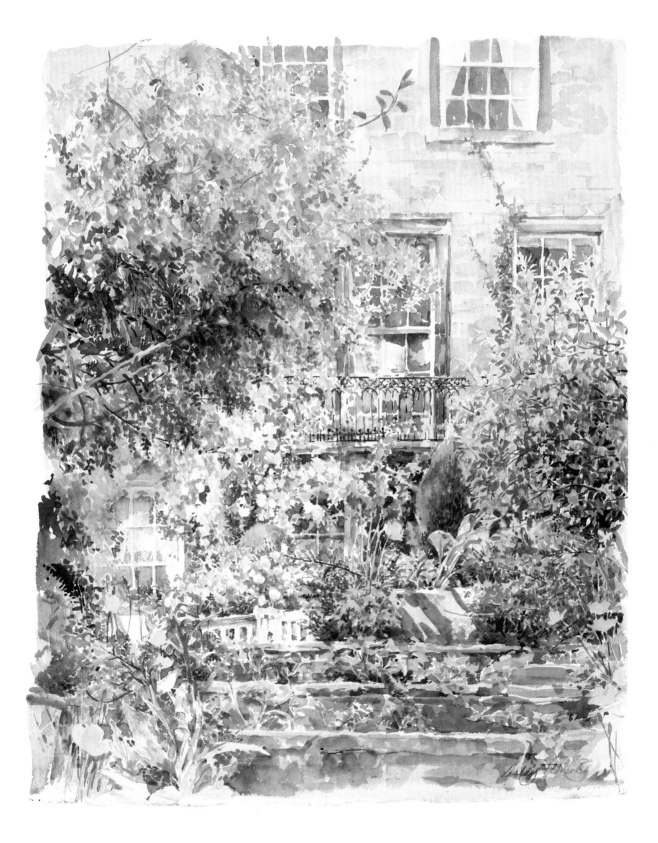

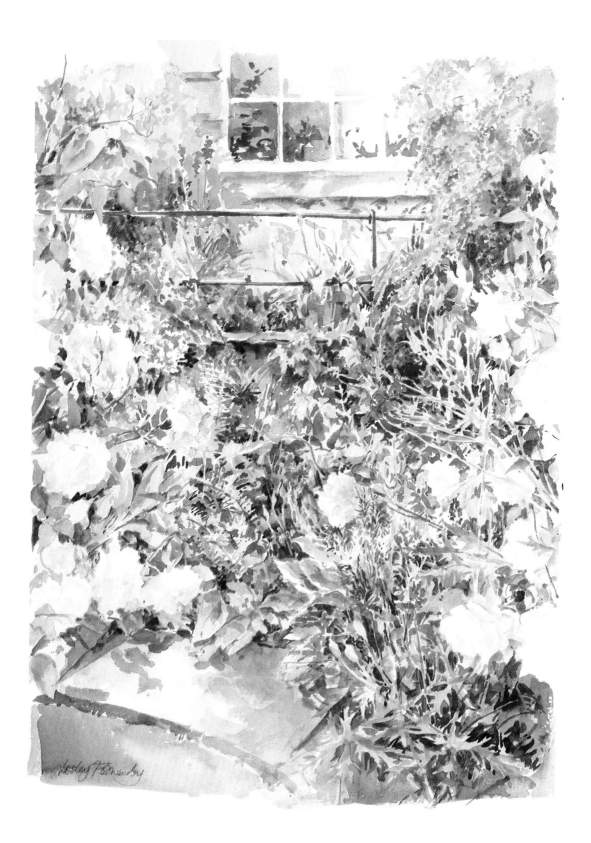

dry, build up a darker area where the shadows are and then you can start to use smaller brush strokes for the texture of the leaves. Vary the intensity of the strokes, closer together in some parts, wider apart in others so that the surface is interesting.

Windows are very important in this composition and I think at this point it is worth looking at them in some detail. Windows appear dark when viewed from the outside, but to think of them just as uniform dark shapes stuck on the outside of a building is to ignore the effects of light and shadows reflecting on to them. They are not separate from the environment you are painting. Look again at the picture on the previous page, where I was quite close to the window and you can see the pattern of the rose bushes on some of the panes and also the sky reflected in the windows, the clouds making parts of them look lighter. Many more windows were visible in the painting we are discussing and so it was even more important to look for any subtle changes in their tone. Imagine what it would have looked like with a lot of deep blue rectangles all the same colour. Sometimes what is inside the house changes the pattern of windows as much as the atmosphere outside and I was helped by the curtains in the top window changing some of the rectangles into triangles and adding extra interest. I have used several blues when mixing colours for the glass. Where I wanted dark areas, I used Ultramarine mixed with a little Brown Madder, and for the lighter parts I either added more water to this mix or used Cerulean on its own or mixed with Brown Madder or Cobalt.

Try this for yourself. Mix a deep colour or use just Ultramarine on its own and paint a series of rectangular shapes all the same colour and depth of tone and then repeat those shapes, varying the tone within each of them,

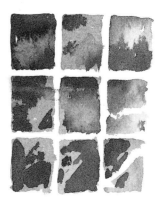

which will make a far more exciting picture, and on a practical level it detracts the eye from any deficiencies there may be in your drawing – putting the insides of windows in and leaving their frames blank is not easy.

This painting was done in mid-June and although I was surrounded by rose bushes, many were still in bud so I chose to sit halfway up the steps and not include them. The painting on the cover of this book I painted about a fortnight later when the bushes were in full bloom, and for this I sat at the bottom of the steps. You can see I hope just how moving such a short distance can radically change a composition. I was able to see the canopy of escallonia above the roses and this has framed the view of the house giving a picture within a picture; I have further accentuated this by exaggerating the shadow cast on to the top steps. I did a preparatory water-colour sketch for this painting, and in it I put only the bare facts I needed to know about the composition, including the colour balance. Notice how much warmer the book cover painting is than the painting on page 134. Also included in the sketch were some reminders to myself of the importance of how the roses were growing and I put in a few reddish-brown lines to show how the branches curved down towards me.

Preliminary sketches do not always work, which is exactly why it is a good idea to do them. Better to find out at this stage that a composition is hopeless than later on! Do not worry if you have sketches or paintings which go wrong. Try to resist the temptation to tear them up because in producing them we always learn *something*. Put them away until you can look at them objectively and think of them as part of the process of producing something worthwhile.

A composition may be radically altered by the effects of light. We saw in the section on shadows how they can make patterns and change existing shapes in the garden, and so when you are searching for a subject they are something you need to think about. In the painting on page 139, the white campanulas and the feverfew shine out because they are planted in the front of a border with a wall behind which casts a shadow over the other plants. When working on a subject like this it is important to be very sure from the start where the white plants will be. If you lose them they are gone for ever. I started by putting in the centres of the individual campanula bells and painted in some of the stems where they were visible.

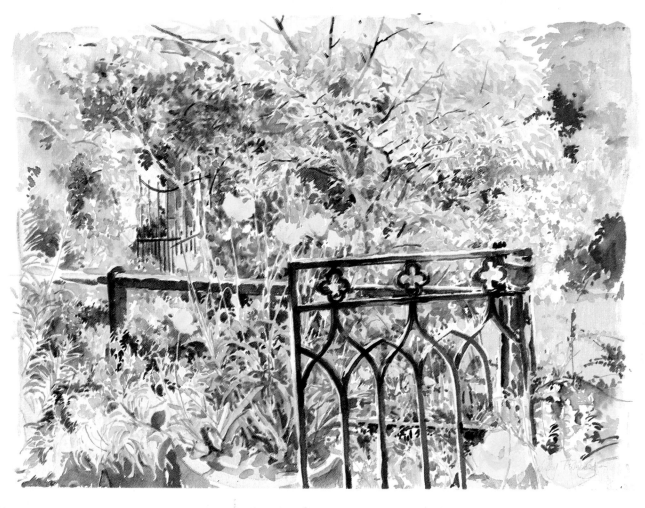

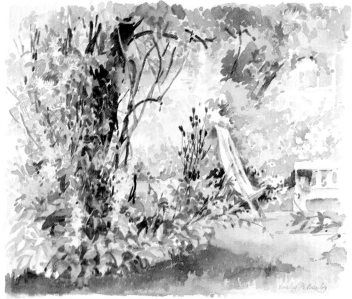

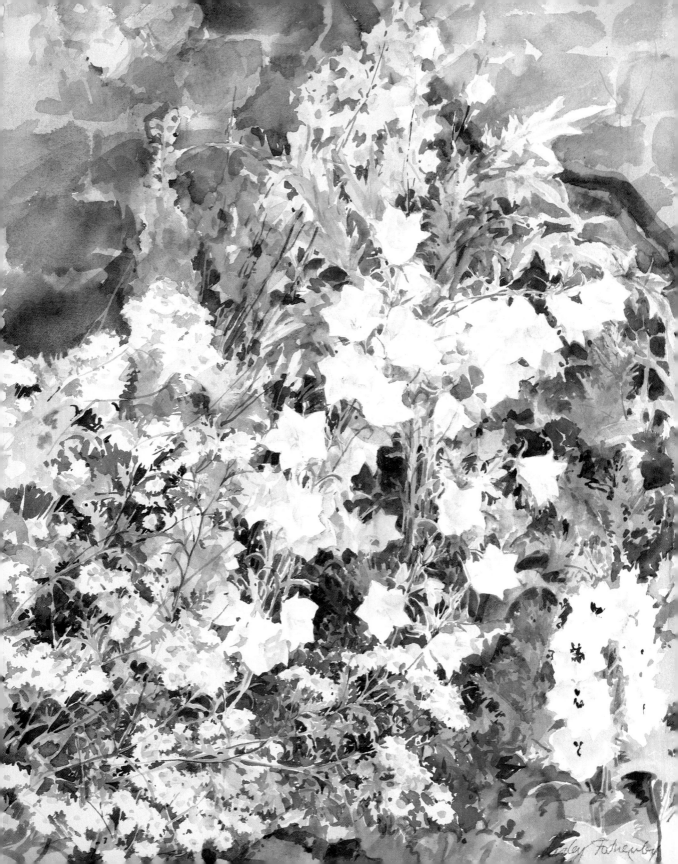

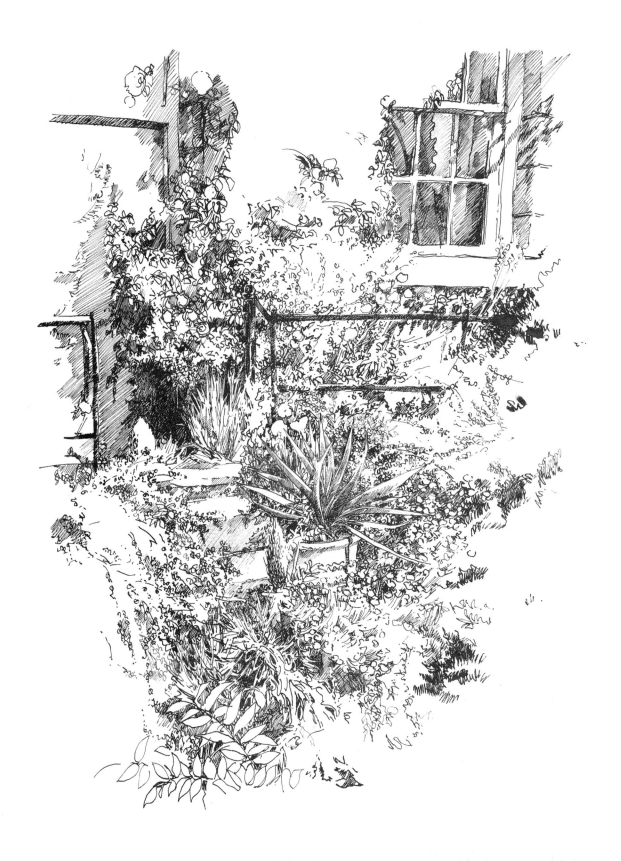

Then I started to build up the background, going backwards and forwards between the flowers in the front and the dark part of the border. I used several washes of colour before I was satisfied that I had made the contrast great enough between the shaded and the light areas.

These are difficult compositions to pull off because the patterns made by the plants are all you have to use and you constantly have to judge which parts to pull forward, which to make recede, and most importantly decide when to stop. I often work on this type of picture outside then bring it home and prop it up somewhere where I will constantly be glancing at it before I add the final touches.

Shadows are an important part of the painting at the bottom of page 138 and I have also used a deck chair to give a focus to the picture. These sorts of things are great to use as they can be moved around, unlike walls and gates, and they give a lived-in feel to a garden. If you compare this picture to the one above it, you will see that it conveys a totally different atmosphere, being much simpler with more flat planes of colour. There is a quieter, more peaceful feeling to it than the one of the gate. In this instance I was interested in all the lines of the stems, branches, railings and gates and in how they intersected and because of this there is a greater feeling of movement and growth; our eye follows one line, then another, then another. I have used very few flat areas of colour and so you will see, by contrasting this picture with the one below, how the way paint is applied to a surface helps to convey the effect you want, as much as the colours you use and the subject matter.

I wrote at the start of this chapter that I spent some days in this garden, and if you have the opportunity I think it is a good idea to take some time discovering and painting one particular garden. You will become familiar with it and notice things that may not have been immediately apparent to you (even if it is your own garden) and it is always a delight to paint a place as it changes and to capture its subtleties.

Summary

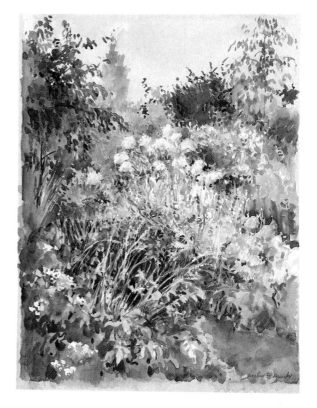

The paintings in this book were done over a period of several years. I spent a lot of time sitting in various gardens in all sorts of weather conditions drawing and painting and I have got enormous pleasure from it. I would like to thank all the people who have so generously let me sit for days on end in their gardens and shared their enthusiasm for them with me.

I know how daunting it can be to go outside with all the problems of sun and rain and midges before you even think of putting paint onto paper but once you have taken the plunge it is well worth experiencing being actually in the environment of the garden with all the smells and sounds to encourage you, and once you have chosen your viewpoint and are able to concentrate on that a lot of your initial fears will go.

I said at the start of the book that you would be familiar with a lot of the ideas I would be discussing and I am sure you realize now how much you knew already about design and colour through planning and working in your garden. Have confidence in this knowledge; it is special to you and will give your paintings and drawings individuality. The techniques I have shown you are basic ones which will make it easier for you to express yourself, use them and adapt them to your own needs. One of the pleasures of gardening is getting your hands dirty, feeling the soil and the plants; using paint and pencils is like this (charcoal in particular if you like getting your hands dirty), there is a pleasure in actually making marks and feeling the pencil or brush on the paper. Enjoy yourself.

Index